Ruthven Todd

WILLIAM BLAKE
The Artist

General editor David Herbert
Studio Vista | Dutton Pictureback

For Lessing J. Rosenwald

A small return for endless generosity
offered with affection and all gratitude

Designed by Gillian Greenwood
Published in Great Britain 1971 by Studio Vista Limited
Blue Star House, Highgate Hill, London N19
and in the United States of America by E.P.Dutton and Co., Inc
201 Park Avenue South, New York, NY 10003
Set in 10 on 11 pt Baskerville
Made and printed in Great Britain
by Richard Clay (The Chaucer Press) Ltd, Bungay, Suffolk
SBN 289 70089 2 (paperback)
SBN 289 70090 6 (hardback)

William Blake: the artist

Although many books have been written about William Blake, it is strange that, until now, so little attention has been paid to his work as a technical innovator. Ruthven Todd has been collecting information about Blake as a technical man for many years and here offers a short report upon his findings. Experimenting over the last twenty-three years, he has not been content to take any statement, unless made by Blake, as a correct explanation. He has also read widely the technical material which would have been available to Blake.

This book, which presents a much shortened and simplified version of some of Ruthven Todd's findings to the present date, is the first to deal with this fascinating aspect of Blake and the first to give creditable explanations of many elusive points which have worried the experts.

Known widely as a poet and Blake scholar, Ruthven Todd started life as a student at Edinburgh Art College before giving up this pursuit in favour of writing. In 1947, in Hayter's famous Atelier 17, he had the opportunity to try out the methods used by Blake in his illuminated printing, with the enthusiastic collaboration of Joan Miró. Author of many books of both prose (*Tracks in the Snow*) and poetry, Ruthven Todd edited Gilchrist's *Life of William Blake* for Everyman's Library in 1942 and again in 1945. At present he is engaged in preparing a completely revised edition, embodying all the new information that has come to light during the last twenty-five years.

Contents

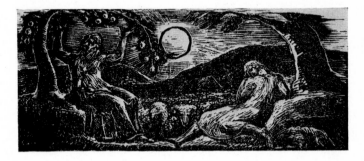

From Virgil's *Pastorals*. Woodcut
$1\frac{5}{16} \times 3\frac{3}{16}$ ins *National Gallery of Art, Washington, Rosenwald Collection*

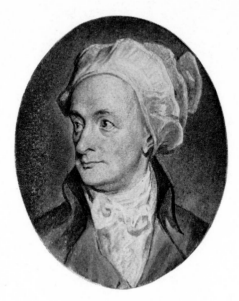

'William Cowper' after George Romney. Watercolor
$2\frac{7}{8} \times 2\frac{5}{8}$ ins. *Ashmolean Museum, Oxford*

Introduction

Here I have tried not only to provide a handbook for those who would like to know something about the manner in which William Blake lived as an artist until his death as an old man aged nearly seventy but also, since I myself have tried to repeat nearly all of his techniques, to suggest some ways in which his highly personal effects might have been achieved.

The chronological form which I have chosen is one which allows me to show the works of Blake's own creation and, also, through the years, the commercial labors which, flowing and ebbing, enabled him to retain his unique identity. This form has the advantage, too, of displaying something of the extraordinary energy to which his output bears witness. Intentionally, although I list important personal events and his books, I have avoided all discussion of his work as a poet.

There are many books upon Blake and for those who will want to look further I have provided basic information about where to start reading in my bibliographical note on p. 155.

Although many famous pictures have been included, I have tried to show pictures of equal quality which are not generally known. This, and much of my information, could never have been achieved without the help of the many people whose names are listed in my acknowledgments on p. 154.

Now all I can hope is that as well as serving its purpose of showing Blake as both a creative and a commercial artist, this brief survey will send readers to look at the originals, and will also persuade them to read the writings which I have had to neglect in such a cavalier fashion.

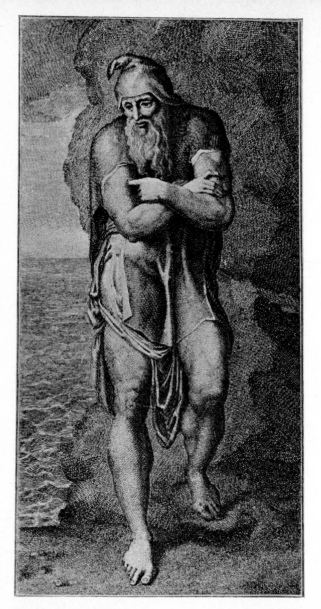

'Joseph of Arimathea among the Rocks of Albion.'
First state of engraving
$10\frac{3}{8} \times 7\frac{5}{8}$ ins *Sir Geoffrey Keynes*

Chronological survey of Blake's life as an artist

1757 November 28, William Blake was born at 28 Broad Street, Golden Square, London, the second son of James Blake, a moderately prosperous hosier.

1765 Blake later recounted of himself that, when about eight or ten years old, he saw his first vision of angels, in a tree, on Peckham Rye, near Dulwich Hill in South London.

1767 Blake's favorite brother, Robert, was born. Blake entered the drawing school run by Henry Pars in the Strand. Here he would have drawn from plaster casts of the antique, and also have made copies of prints and drawings. Even at this early date, Blake started collecting engravings on his own, being encouraged by the friendly auctioneer Abraham Langford, in Covent Garden.

1772 Blake was indentured as an apprentice to the engraver James Basire for the term of seven years, in the consideration of £52 10s for the whole period. The only known copy of the first state of the engraving later known as 'Joseph of Arimathea among the Rocks of Albion', now in the collection of Sir Geoffrey Keynes, bears the inscription in Blake's hand, 'Engraved when I was a beginner at Basires / from a drawing by Salvati after Michael Angelo'. As a beginner Blake was largely occupied with work for the Society of Antiquaries, to whom Basire was the official engraver.

1774 Owing, it would seem, to disagreements among the apprentices, Blake was sent to spend much of his time in Westminster Abbey, making preliminary drawings for Richard Gough's *Sepulchral Monuments in Great Britain*, published in 1786. Although both the drawings and engravings bear the signature of Basire, Blake himself was responsible for at least eight of the plates. Sir Geoffrey Keynes has recently suggested the addition of eleven more. The drawings and copperplates of this work are now in the Bodleian Library, Oxford. Among other works handled by Basire's workshop during his years of apprenticeship, it is generally accepted that Blake designed as well as engraved several items for Jacob Bryant's *A New System, or, an Analysis of Ancient Mythology*, 1774–76.

1776 Blake made a sketch in oils, the only known work by him in the medium, after the figure on the extreme left of those

'Last Judgment' after Michelangelo. Sketch in oils
20½ × 12⅟₁₆ ins *Huntington Library and Art Gallery*

'The Penance of Jane Shore.' Ink and watercolor drawing
$9\frac{5}{8} \times 11\frac{5}{8}$ ins *Tate Gallery*

rising from the dead in Michelangelo's 'Last Judgment'. It was probably about this date that Blake started teaching his younger brother, Robert, the rudiments of drawing.

1779 Blake's apprenticeship to Basire ended at the beginning of August, but he must already, in July, have submitted a drawing and a testimonial from a recognized artist to George Moser, Keeper of the ten-year-old Royal Academy since, after the customary three months probation, he was admitted as a full-time student on October 8, at the age of 22.

The early drawing in ink and watercolor of 'The Penance of Jane Shore', probably that now in the collection of Sir Henry Verney, can be assigned to this year. A later version, varnished, is in the Tate Gallery.

1780 Blake exhibited, for the first time in the Royal Academy, a watercolor, 'The Death of Earl Godwin'. Although this drawing has disappeared a small watercolor sketch of the subject exists.

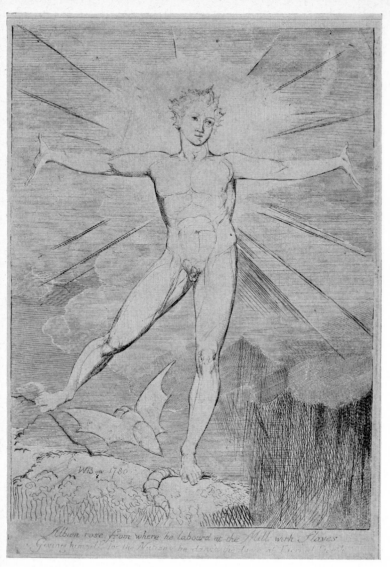

Albion rose from where he laboured at the Mill with Slaves
Giving himself for the Nations he danc'd the dance of Eternal Death

'The Dance of Albion.' Engraving
10¾ × 7¾ ins *National Gallery of Art, Washington, Rosenwald Collection*

The engraving 'The Dance of Albion' is inscribed 'W B inv 1780'. The print is also known as 'Glad Day'. About 1794–95,

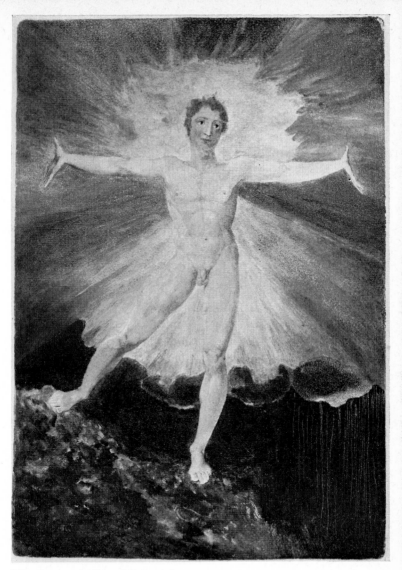

'The Dance of Albion.' Color print
$10\frac{3}{4} \times 7\frac{9}{16}$ ins *British Museum*

Blake reissued the plate as a color print, in his personal technique which is discussed below.

'The Death of Earl Godwin.' Watercolor
5 × 7⅛ ins *British Museum*

The earliest example so far traced of his own published work as a commercial engraver is the plate after J.Roberts, in J.Olivier's *Fencing Familiarized.*

About this time he formed three life-long friendships. These were with John Flaxman, the sculptor, Henry Fuseli, the painter, and George Cumberland, connoisseur, writer and part-time artist. The last, writing under the name of 'Candid', drew favorable attention to Blake's drawing in the Royal Academy, in the *Morning Chronicle and London Advertiser*, May 27. Although the friendship was later to be destroyed, Blake also became intimate with the prolific Thomas Stothard, after whom he was to make many engravings.

1782 August 18, William Blake married Catherine Boucher (or Butcher), daughter of a market gardener in Battersea, in the church of St Mary, Battersea. The young couple set up house, probably as lodgers, in 23 Green Street, Leicester Fields, not far from the house of Sir Joshua Reynolds. Among a number of engravings after Stothard which were done in this year are illustrations to Samuel Richardson's *The History of Sir Charles Grandison*, and the frontispiece for John Bonny-castle's *An Introduction to Mensuration.*

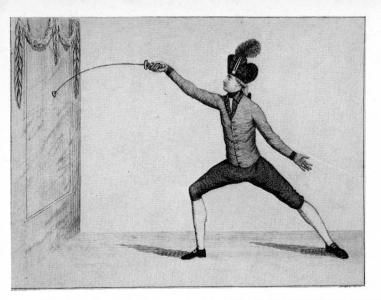

'Fencing 4th position' from
Olivier *Fencing Familiar* 1786.
Engraving $5\frac{7}{8} \times 8\frac{1}{4}$ ins
Princeton University Library

From Richardson *The
History of Sir Charles Grandison*.
Engraving after Stothard
$6\frac{1}{4} \times 4\frac{1}{8}$ ins
Princeton University Library

From J. Ritson *A Select Collection of English Songs*. London 1783.
Engraving $2\frac{7}{16}$ × $3\frac{7}{16}$ ins *Princeton University Library*

1783 The poems which Blake had been writing from about
1770, but mostly during the years of apprenticeship, were
printed, with the backing of John Flaxman and his patroness,
Mrs Harriet Mathew, wife of the Rev. A.S.Mathew: *Poetical
Sketches. By W.B. London: Printed in the Year* M DCC LXXXIII.
It would seem that the major part of the edition was given to
Blake but that he showed little interest in passing it around.

In the Royal Academy he showed two watercolors, 'A
Breach in a City, the Morning after a Battle', and 'War Un-
chained by an Angel, Fire, Pestilence and Famine following'.

The commercial works of this year included plates after
Stothard for both Joseph Ritson's *A Select Collection of English
Songs*, and for John Hoole's translation of Ludovico Ariosto's
Orlando Furioso, as well as a large separate plate, after the same
artist, 'The Fall of Rosamund'. This plate provides us with the
only record of what Blake was probably paid in this early
period. The publisher Thomas Macklin gave him £80, at a
time when he was paying the fashionable Francesco Bartolozzi
upward of £200 a plate.

From Ariosto *Orlando Furioso*. Engraving 5⅞ × 4⅛ ins *Thomas Minnick*

'Joseph's Brethren bowing down before him.' Watercolor
$15\frac{7}{8} \times 22\frac{1}{8}$ ins *Fitzwilliam Museum, Cambridge*

1784 On April 26, John Flaxman sent a copy of *Poetical Sketches* to his new friend William Hayley, mentioning a suggestion that a subscription should be raised to send Blake to Rome to finish his studies as an artist. Nothing came of this and Blake never left England.

On July 4, his father died. In the autumn Blake moved back to the street of his birth, 27 Broad Street, where he set up a print-shop in partnership with his former fellow-apprentice, James Parker. Presumably, what little business there was consisted of the sale of prints by others. Only two plates are known to have been published by the partners, both engraved by Blake after Stothard, 'Zephyrus and Flora', and 'Calisto'.

The incomplete satire *An Island in the Moon*, was probably written about this time.

1785 Blake was still in Broad Street when he showed four watercolors at the Royal Academy, 'Joseph's Brethren bowing down before him', 'Joseph ordering Simeon to be bound', 'Joseph making himself known to his Brethren', and 'The Bard, from Gray'. The last has not been traced.

In the autumn, Blake and his wife moved to 28 Poland Street. A few doors away was the public house, now known as

length of time, any bubbles that appeared around the design being removed with a feather. Judging from the depth to which Blake bit the only remaining fragment of any of his plates, a corner of a cancelled plate for *America* in the National Gallery of Art: Rosenwald Collection, I would estimate that, according to the temperature of the room in which the biting was being done, it would take from about six to eight hours.

Inking the bitten plate, once all ground and protective varnish had been removed, presented a problem. The use of an ordinary roller would inevitably spread ink on to the bitten background, where it was not wanted. However, an unused plate could be inked all over and placed upon the etched plate. The two plates would be pressed together, possibly by running them through the press without much pressure. The plates separated, the etched one could be printed with the press set so that it would not bear too heavily on the paper, which did not need to be soaked, as for ordinary intaglio printing, but should have been just moist enough to accept the ink readily. Printing could be done in an etching-press, or, raised to type-height, in a printer's proofing press. Proofs could even be obtained by the simple method of rubbing the verso of the paper with the back of a large spoon or some similar object adapted to the purpose.

Among Blake's commercial works were a frontispiece, after Fuseli, for John Caspar Lavater's *Aphorisms on Man*. This book intrigued Blake so much that he covered his own copy with annotations. Another book he treated in the same way was Swedenborg's *Wisdom of Angels concerning Divine Love and Divine Wisdom*.

Separate plates were a large one after Hogarth, 'Beggar's Opera, Act III', and two after George Morland, 'The Industrious Cottager' and 'The Idle Laundress'.

1789 The first of Blake's symbolical books, *Tiriel*, probably belongs to this year. The existence of nine drawings, out of twelve known in 1863, suggests that he may have intended to have the book printed in type and to engrave the twelve drawings himself as accompaniment to the text.

'Tiriel borne on the shoulders of Ijim.' Drawing
Victoria and Albert Museum

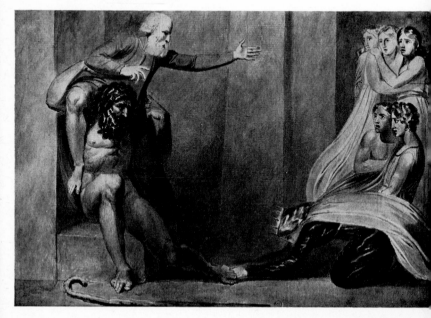

Vignette from H. C. Lavater
Essays on physiognomy
London 1789–1798. Engraving
5⅞ × 2¾ ins *Princeton University Library*

The supremely original productions of this year were *Songs of Innocence* (usually thirty-one plates) and *The Book of Thel* (eight plates). His skill had increased vastly since he had first used his method for the two little books of aphorisms of the previous year. That he had not quite managed to control his nitric acid, which, heating up in action against the copper tends also to lift an asphaltum-based ground, can be seen by holding some of the prints against a slanting light. Traces of retouching, either with watercolor or colored ink, can then be noted.

Commercially, he did three engravings for John Caspar Lavater's *Essays on Physiognomy*, including a tail-piece.

1790 Still concerned with Swedenborg, Blake annotated his copies of that writer's *Wisdom of Angels concerning Divine Providence and Heaven and Hell*.

It is likely that he started work on his own *The Marriage of Heaven and Hell* in this year, although it is also probable that the book was not finished until 1793 (it contains 24 plates or, with the addition of the later *A Song of Liberty*, 27).

'The Lamb' from *Songs of Innocence and Experience*
4⅝ × 2¾ ins *Library of Congress, Rosenwald Collection*

But he that loves the lowly, pours his oil upon my head.
And kisses me, and binds his nuptial bands around my breast.
And says; Thou mother of my children, I have loved thee
And I have given thee a crown that none can take away
But how this is sweet maid, I know not, and I cannot know,
I ponder, and I cannot ponder; yet I live and love.

The daughter of beauty wip'd her pitying tears with her white veil,
And said. Alas! I knew not this, and therefore did I weep:
That God would love a Worm I knew, and punish the evil foot
That wilful, bruis'd its helpless form: but that he cherish'd it
With milk and oil, I never knew; and therefore did I weep,
And I complaind in the mild air, because I fade away,
And lay me down in thy cold bed, and leave my shining lot.

Queen of the vales, the matron Clay answerd; I heard thy sighs.
And all thy moans flew oer my roof, but I have calld them down:
Wilt thou O Queen enter my house, 'tis given thee to enter,
And to return; fear nothing, enter with thy virgin feet.

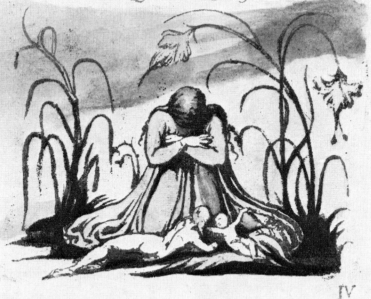

Plate IV from *The Book of Thel*
6⅛ × 4⅝ ins *Fitzwilliam Museum, Cambridge*

25

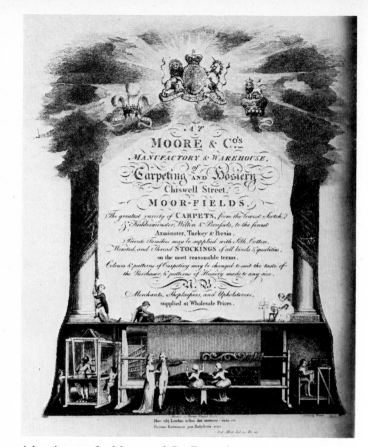

Advertisement for Moore and Co. Engraving
$10\frac{7}{8} \times 9\frac{7}{8}$ ins *British Museum*

One of Blake's stranger ventures was the plate of 'Moore & Co's Advertisement'. There is no record to help explain how he came to both design and engrave this strictly commercial plate, of which only one example seems to be known.

According to John Knowles, the first biographer of Henry Fuseli, Blake started to engrave two plates after that artist: 'Satan taking his flight from Chaos', and 'Adam and Eve observed by Satan'. These were meant for a projected edition of Milton to be edited by William Cowper. The onset of madness in the editor caused the proposal to be abandoned, and no proofs of these plates have been traced.

ORIGINAL STORIES
FROM
REAL LIFE;
WITH
CONVERSATIONS,
CALCULATED TO
REGULATE THE AFFECTIONS,
AND
FORM THE MIND
TO
TRUTH AND GOODNESS.
BY MARY WOLLSTONECRAFT.

LONDON:
PRINTED FOR J. JOHNSON, NO. 72, ST.
PAUL'S CHURCH-YARD.
1791.

'Look what a fine morning it is.' Frontispiece for Mary Wollstonecraft
Original Stories from Real Life. Engraving
$4\frac{5}{8} \times 2\frac{1}{2}$ ins *Princeton University Library*

In the autumn Blake and his wife moved to 13 Hercules
Buildings, Lambeth, where he had sufficient working space
for the first time in his life.

1791 The first part of an intended poem in seven parts, *The
French Revolution*, was set up in ordinary type for the book-
seller and publisher Joseph Johnson. In view of the political
situation matters went no further. The only existing proof
copy is in the Huntington Library. No manuscript of the other
parts has been found.

Commercially, Blake was well employed. He designed as
well as engraved six illustrations for Mary Wollstonecraft's
Original Stories from Real Life. Among the other books for which
he engraved was the anonymous first edition of Erasmus
Darwin's *The Botanic Garden*, doing one plate; 'The Fertiliza-
tion of Egypt', after Fuseli, and drawing as well as engraving
illustrations of the Portland Vase. These last, although un-
signed, have always been accepted as Blake's work. The frontis-
piece for David Hartley's *Observations on Man*, engraved after
Shackleton, also seems to have been on sale as a separate plate.

Where the cold miser spreads his gold? or does the bright cloud
On his stone threshold? does his eye behold the beam that brings
Expansion to the eye at pity? or will he bind himself
Beside the ox to thy hard furrow? does not that mild beam blot
The bat. the owl, the glowing tyger. and the king at night.
The sea fowl takes the wintry blast. for a covering to her limbs:
And the wild snake, the pestilence to adorn him with gems & gold.
And trees & birds & beasts. & men. behold their eternal joy.
Arise you little glancing wings, and sing your infant joy!
Arise and drink your bliss, for every thing that lives is holy!

Thus every morning wails Oothoon. but Theotormon sits
Upon the margind ocean conversing with shadows dire.

The Daughters of Albion hear her woes. & eccho back her sighs.

The End

Last page from *Visions of the Daughters of Albion*
6 11/16 × 4 11/16 ins *Library of Congress, Rosenwald Collection*

 In October he was invited by Willey Reveley, editor of the
third edition of Stuart and Revett's *Antiquities of Athens*, to
engrave plates for it after William Pars, brother of his first
teacher, by the end of the following January. This he agreed to
try to do, but all four of Blake's plates are dated April 3, 1792,
and the book itself did not appear until 1794.
1792 Blake's mother, Catherine, about whom little is known,

What time the thirteen Governors that England sent con- -vene
In Bernards house; the flames coverd the land, they rouze they
cry
Shaking their mental chains they rush in fury to the sea
To quench their anguish; at the feet of Washington down falln
They grovel on the sand and writhing lie, while all
The British soldiers thro' the thirteen states sent up a howl
Of anguish: threw their swords & muskets to the earth & run
From their encampments and dark castles seeking where to hide
From the grim flames; and from the visions of Orc; in sight
Of Albions Angel; who enrag'd his secret clouds opend
From north to south, and burnt outstretchd on wings of wrath cov'ring
The eastern sky, spreading his awful wings across the heavens;
Beneath him rolld his numrous hosts, all Albions Angels campd
Darkend the Atlantic mountains & their trumpets shook the valleys
Armd with diseases of the earth to cast upon the Abyss,
Their numbers forty millions, mustring in the eastern sky.

Plate from *America, A Prophecy*
$9\frac{7}{16} \times 6\frac{11}{16}$ ins *New York Public Library*

died at the age of seventy and was buried in Bunhill Fields.
1793 Using his established method of production, Blake issued
Visions of the Daughters of Albion (11 plates) and *America* (18
plates). He also produced a small volume of eighteen engraved
plates, *For Children: The Gates of Paradise*. This he was to re-
issue some quarter of a century later with additional plates,
legends and an amplified text.

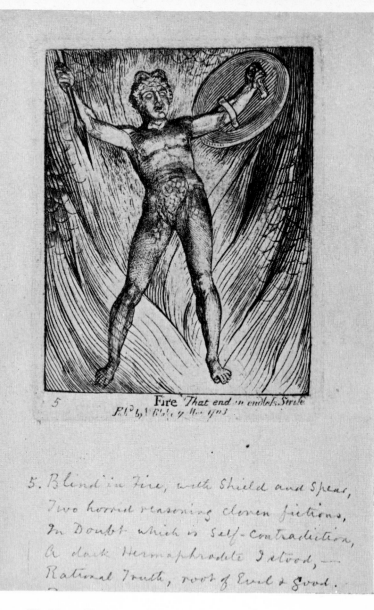

'Fire' from *The Gates of Paradise*. Etching
4⅝ × 3½ ins *Mr and Mrs Paul Mellon*

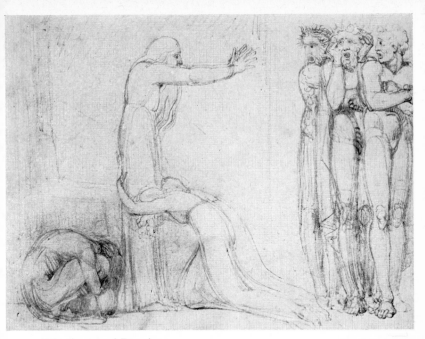

'The Accusers.' Drawing
7 × 9⅜ ins *Whitworth Art Gallery, Manchester University*

In this year he started using the *Notebook*, sometimes known as *The Rossetti MS*. He issued also *A Prospectus: To the Public October 10, 1793*, which has not been seen since about 1860; in this he announced 'The History of England, a small book of Engravings. Price 3s'. This was amplified in the *Notebook* where he listed twenty-six possible subjects. Although no engravings of any of the subjects are recorded, some of them are known in watercolor.

Founding his work upon a part of an earlier drawing, Blake made his engraving of 'The Accusers of Theft, Adultery, Murder'.

On August 18, he published the second state of 'The Complaint of Job', which is completely different from the plate of 1786. He must have rubbed down the whole surface until only outlines remained, and the conception has been altered to make the effect more dramatic.

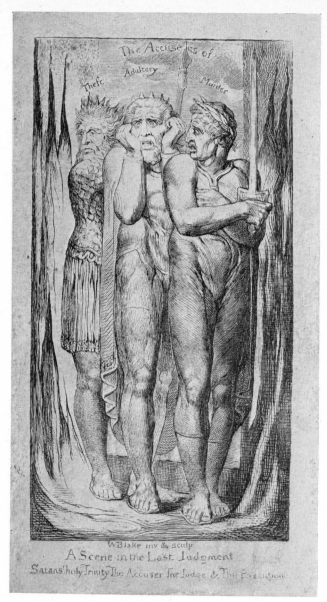

'The Accusers.' Line engraving
$8\frac{5}{8} \times 4\frac{3}{4}$ ins *National Gallery of Art, Washington, Rosenwald Collection*

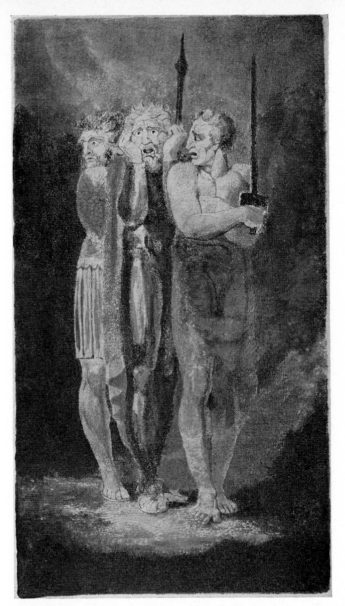

'The Accusers.' Colored print from large book of designs
$8\frac{5}{8} \times 4\frac{3}{4}$ ins *National Gallery of Art, Washington, Rosenwald Collection*

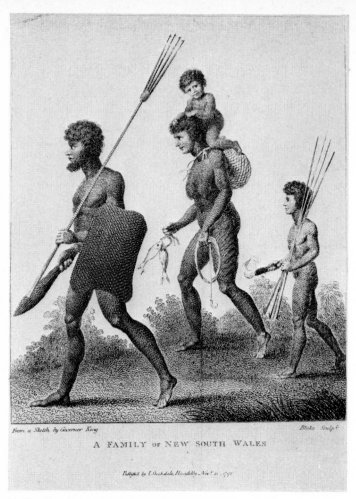

From a Sketch by Governor King Blake Sculp.t

A FAMILY OF NEW SOUTH WALES

Published by I. Stockdale, Piccadilly, Nov.r 10 1798

'A Family of New South Wales.' Engraving
Princeton University Library

An example of his commercial work is the plate he engraved, after a sketch by Governor King, for John Hunter's *An Historical Journal of the Transactions at Port Jackson and Norfolk Island.*

This year probably marked the beginning of Blake's friendship with his most steadfast patron, Thomas Butts.

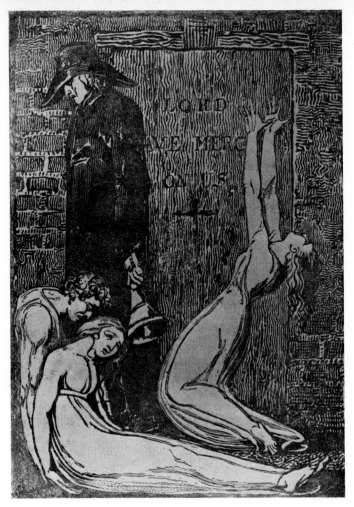

'The Bellman', plate 7 from *Europe*
9¼ × 6¾ ins *Sir Geoffrey Keynes* (Photo: Kerrison Preston)

1794 Two of his own illuminated prophetic books were issued:
Europe (18 plates), *The First Book of Urizen* (28 plates, one of
which is illustrated on the back cover of this book); no sub-
sequent books appeared and in the latest to which a date can
be given, Blake has erased the word 'First'. He also issued more
of his own poems in the collection *Songs of Experience* (23 plates).

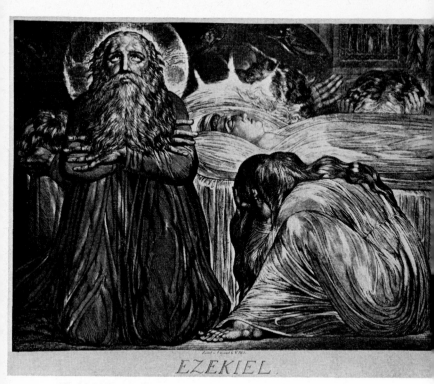

EZEKIEL

'Ezekiel.' Engraving
18⅝ × 21½ ins *Sir Geoffrey Keynes*

This last was not meant to be issued separately, but was com-
bined with *Songs of Innocence*, with a title-page *Songs of Innocence
and of Experience*. In all earlier copies, Blake rearranged the
poems according to his mood, transferring some from the first
to the second book.

The plate 'Ezekiel: I take away from thee the Desire of
thine Eyes' is clearly a companion print to 'The Complaint

of Job' of 1793, although Ezekiel is known only from one state, dated October 27, 1794.

It was probably about this time that Blake wrote in the *Notebook:* 'To Wood-cut on Pewter: lay a ground on the Plate & smoke it as for Etching; then trace your outlines, and beginning with the spots of light on each object with an oval pointed needle scrape off the ground as a direction for your graver; then proceed to graving with the ground on the plate, being as careful as possible not to hurt the ground, because it, being black, will shew perfectly what is wanted'. One cannot tell whether this was written before or after he engraved the first state of 'The Man Sweeping the Interpreter's Parlour', but it is a clear and simple description of the process he used.

In this year Blake became friendly with a retired Captain, John Gabriel Stedman, who was writing a book about Surinam for which Blake engraved plates.

1795 Deserting his relief etching briefly Blake reverted to ordinary intaglio etching and produced *The Book of Los* (five plates) and *The Book of Ahania* (six plates). Apparently he was not satisfied with the results, for only one copy of each is known, the former in the Library of Congress: Rosenwald Collection and the latter in the British Museum.

In *The Song of Los* (eight plates) Blake seems to have been experimenting with his new method of color printing. There are many details about this technique which still need full experimental research, but it would seem certain that Blake first used the method with plates selected from his illuminated books. The copperplates were kept warm on the coal-burning kitchen-range, as were the colors, mixed into his glue-tempera. These pigments, in this state, were not as thick as the results would suggest. Blake always used a camel, i.e. ox or squirrel, hair brush and disliked sable (there is no mention of his using hog or bristle brushes, although these were available to him). Once the pigment had been applied to the plate, a print was obtained by light pressure, such as could be given by the hand, upon the back of the paper. Any press would not only flatten the colors, but would also spread them messily. The paper would be peeled from the plate, displaying the characteristic reticulated surface, and any retouching or finishing, done by hand would, naturally, lack this surface.

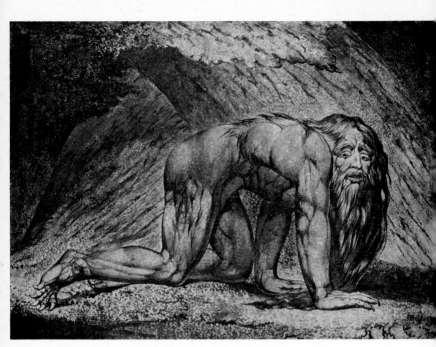

'Nebuchadnezzar.' Color printed drawing
16 15/16 × 23 3/4 ins *Minneapolis Institute of Arts*

Success with the copperplates led Blake on to making a series
of large 'Color Printed Drawings'. Theoretically, the method
was capable of producing many copies, but most of the prints
exist in either two or three copies while one is supposed to be
unique. Since each print was finished by hand and was an
original work, differing from any other, it is likely that Blake
had at least two reasons for limiting them. The most important
was that his imagination was pressing him to create fresh
work, and the other was the failure to find purchasers, for
Thomas Butts did not acquire his until ten years after they

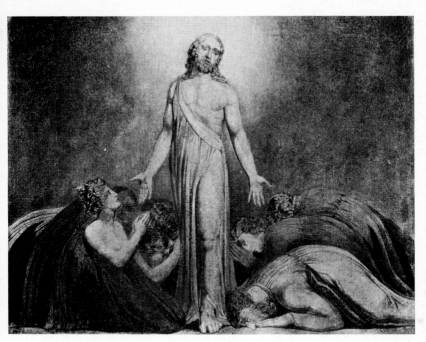

'Christ appearing to the Apostles after the Resurrection.' Color printed drawing
17 × 22½ ins *Yale University Art Gallery*

had been made. As late as 1818, in a letter to Dawson Turner, the Yarmouth antiquarian and connoisseur, he offered the set of twelve at £5 5s each. This suggests that there may still be a second copy of the supposedly unique 'God judging Adam' waiting to re-emerge.

The series consists of 'Elohim Creating Adam', 'Lamech and his Two Wives', 'God Judging Adam' (which has only recently been identified, as, previously, it was supposed to represent 'Elijah in the Fiery Chariot'), 'Nebuchadnezzar', 'Christ Appearing to the Apostles after the Resurrection',

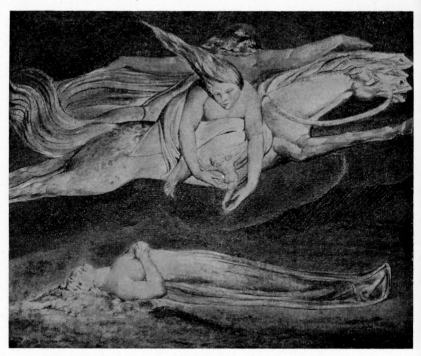

'Pity' from Shakespeare's *Macbeth*. Color printed drawing
$16\frac{9}{16} \times 20\frac{3}{4}$ ins *The Metropolitan Museum of Art, New York
Gift of Mrs Robert W. Goelet, 1958*

'The Good and Evil Angels', 'Pity like a Naked New-Born
Babe', 'The Triple Hecate', 'The House of Death' (also called
'The Lazar House'), 'Newton', 'Naomi entreating Ruth and
Orpah to return to the Land of Moab', and 'Satan Exulting
over Eve'.

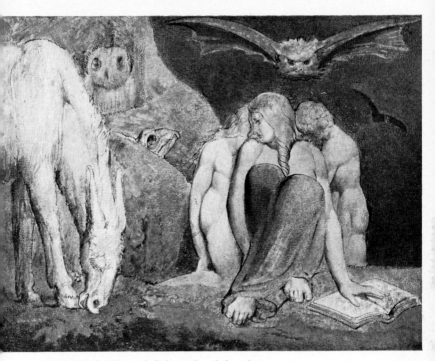

'The Triple Hecate.' Color printed drawing
$16\frac{15}{16} \times 22\frac{5}{8}$ ins *National Galleries of Scotland*

It seems, too, that in this year of inventiveness, Blake's watercolor technique began to change. Instead of making 'tinted drawings', where color was applied over a drawing in monochrome wash, he, like his contemporaries, became aware of the power of the direct use of color upon white paper.

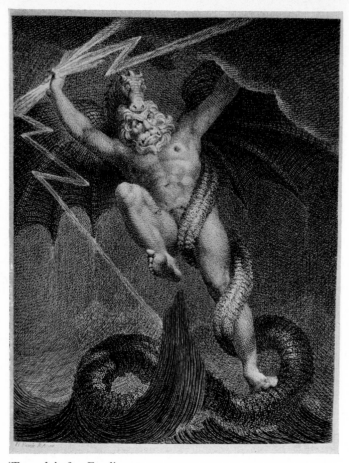

'Tornado' after Fuseli
$8\frac{1}{4} \times 6\frac{5}{8}$ ins *Westminster Public Library*

A book illustration of this year is 'Tornado', after Fuseli, added to the third edition of Erasmus Darwin's *The Botanic Garden*.

About this time Blake started the immense poem, on large sheets of paper from various sources, *Vala* or *The Four Zoas*, which he probably continued until 1806. It contains both text and drawings. Some of the latter seem to have no obvious connection with the poem.

And the leopards coverd with skins of beasts tended the roaring fires

35 The tygers of wrath called the horses of instruction from their mangers
They unlooosd them & put on the harness of gold & silver & ivory
In human forms distinct they stood round Urizen prince of light

Rattling the adamantine chains & hooks heave up the ore

In mountainous masses, plungd in furnaces, & they shut & seald
The furnaces a time & times; all the while blew the North
His clouds bellows & the South & East & dismal West
And all the while the plow of iron cut the dreadful furrows

Luvah was cast into the Furnaces of affliction & sealed
And Vala fed in cruel delight, the furnaces with fire
Stern Urizen beheld urgd by necessity to keep
The evil day afar, & if perchance with iron power
He might avert his own despair; in woe & fear he saw

Vala
16 15/16 × 13 13/16 ins British Museum

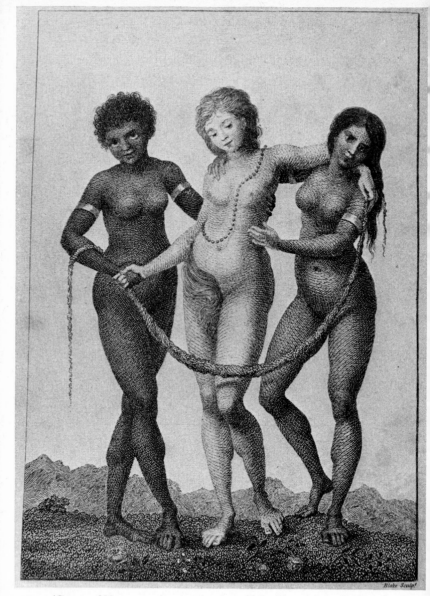

'Group of Negroes as imported to be sold for Slaves' from Stedman's *Narrative*
$7\frac{3}{10} \times 5\frac{3}{16}$ ins *Westminster Public Library*

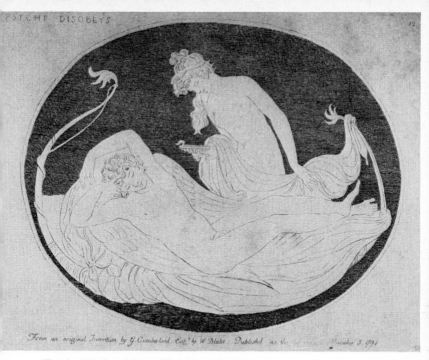

From an original Invention by G. Cumberland, Esq.ʳ by W Blake : Published as th... ...vember 5. 1794

'Psyche Disobeys' from *Thoughts on Outline*
$6\frac{7}{8} \times 8\frac{1}{4}$ ins *Westminster Public Library*

1796 Despite the turmoil of new ideas of the previous year, Blake had started, and managed to complete before the end of this year, the series of 537 drawings around the text to illustrate Edward Young's *The Complaint and the Consolation; or, Night Thoughts.*

Captain J.G. Stedman's *Narrative, of a Five Years' Expedition, against the Revolted Negroes of Surinam, in Guiana,* appeared, containing eighty-six plates. Ten of these are signed by Blake and at least three more are certainly by him.

Proof that his reputation as an original artist as well as an engraver was increasing seems to be given in the fact that another, Perry, was engaged to engrave, after Blake's designs, the frontispiece and tail-piece for a new edition of Gottfried Augustus Bürger's *Leonora.*

Although, like those for Stedman's book, the plates had been engraved some time earlier, George Cumberland's *Thoughts on*

Outline, with eight plates engraved by Blake after the author, was not published until now. It must have seemed to Blake that he was finally beginning to receive the recognition he deserved.

George Cumberland's *Some Anecdotes of the Life of Julio Bonasoni* had been published in 1793, but Blake's engraving, although easier and more fluid, still reflected the influence of Basire. Only in his 'Illuminated Books' could he demonstrate his domination of the copperplate.

1797 Edward Young's *Night Thoughts*, containing forty-three marginal engravings by Blake after his own designs, was published. It proved a failure, perhaps as much on account of the insecurity caused by wars and threats of wars as by any real objection to the book on artistic grounds.

Much has been written about the amount that Blake was paid for the drawings and the engravings. His contemporary Joseph Farington, stated in his diary that Blake accepted £21 for *Night Thoughts* from Richard Edwards, the Pall Mall bookseller who specialized in the publication of expensive books of prints. The late Col.W.E.Moss, in private correspondence, suggested that this sum was paid for the copyright only and that Edwards undoubtedly paid him another, and larger sum for 537 drawings. These remained in the possession of the Edwards family for nearly a century. I tend to accept the word of the mildly crazy Richard C.Jackson, whose family had certainly known Blake, that he was paid £40 for the engraving of each plate. Even that, judging from contemporary payments to other engravers, was a miserable sum, but Blake was obviously hoping that in due course he would engrave all the drawings. In addition, he seemed certain that he would make extra money by selling copies colored in watercolor. A considerable number of such copies exist today. One of the two colored copies belonging to Mr and Mrs Paul Mellon bears the inscription, 'This copy coloured for me by Wm Blake——W.E.'.

That his reputation as an engraver stood high is shown by his being asked to sign a testimonial for Alexander Tilloch, a Scottish journalist, Biblical controversialist and inventor, who had devised a means of thwarting the would-be forger of bank-notes. The testimonial was signed by nineteen engravers, including Francis Bartolozzi, James Heath, James Fittler,

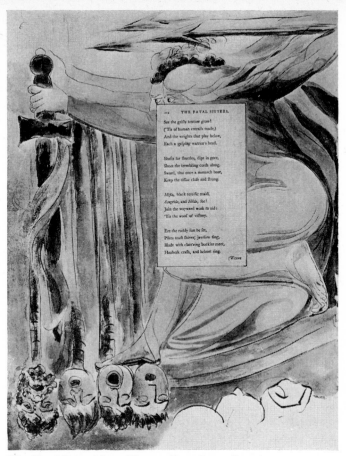

'The Fatal Sisters' from Thomas Gray *Poems*. Drawing
16½ × 12⅝ ins *Mr and Mrs Paul Mellon*

J.Landseer, James Basire, William Sharp and Wilson Lowry,
as well as by one 'W.S.Blake, (Writing Engraver)', and
William Blake. An extant copy of the leaflet adds 'The
Visionary Artist' after the name of Blake, thus distinguishing
him from the writing engraver whose works were often, in the
early days of Blake studies, confused with those of the artist.
In this same year he was commissioned by John Flaxman to
make an illustrated copy of Thomas Gray's *Poems*. The 116
drawings were presented to Flaxman's wife, Nancy, before
September 1805.

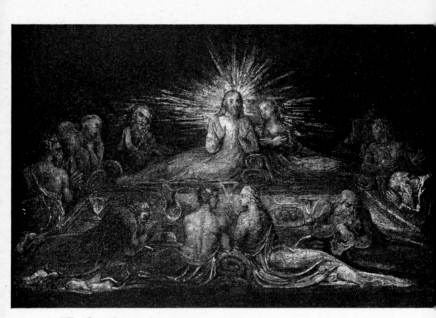

'The Last Supper.' Tempera on canvas
12 × 19 ins *National Gallery of Art, Washington, Rosenwald Collection*

1798 Undoubtedly Blake must have felt depressed by the failure of *Night Thoughts*, a venture from which he had expected so much. Only eight plates, of little interest, unsigned, but after H.Fuseli dated December 1, 1797, were published commercially this year. They appeared in Charles Allen's *A New and Improved History of England* and *A New and Improved Roman History*, four to each book.

Using many pages of the *Night Thoughts* which bear the engravings without the text, he went on working on his poem *Vala*.

1799 In the May exhibition of the Royal Academy Blake showed 'The Last Supper'. This is untraced, but may have been the tempera on canvas shown with the drawings and watercolors rather than with the oil paintings.

George Cumberland seems to have introduced him to the Rev. Dr John Trusler, who wanted a watercolor showing

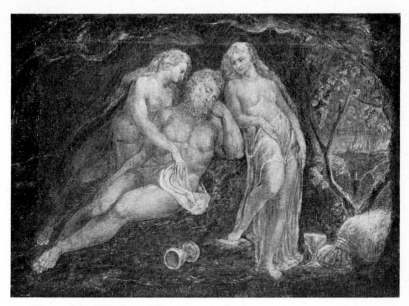

'Lot and his Daughters.' Tempera
10¼ × 14⅞ ins *Huntington Library and Art Gallery*

'Malevolence'. Dr Trusler had firm ideas on the subject, which does not seem to have had much appeal to Blake. His drawing is derivative from at least two earlier works. The Rev. Doctor did not know about this, but did know that the drawing was not what he wanted. Neither of the letters which Blake wrote him could have been considered conciliatory.

Owing to Blake's inconsistency in dating his works, it is hard to place them in a chronology. Small early temperas on canvas are dated 1799, and these fit stylistically with others which bear no dates. Most of these small paintings seem to have been made for Thomas Butts who seems, at this period, to have had some idea that Blake might, in time, illustrate the whole Bible.

Although undated, 'Lot and His Daughters', is fairly typical of these Biblical temperas. Others in the series include 'Bathsheba at the Bath' and 'Christ Blessing Little Children', both in the Tate Gallery, 'The Adoration of the Kings', Brighton

Art Gallery, 'St Luke', George Goyder, and 'Christ's entry into Jerusalem' in Glasgow.

The prolongation of the war with France and uncertainty at home, made this a bad time for booksellers (who were also publishers at that period) and for engravers. There seemed to be little buying public left. A smaller fourth edition of Darwin's *Botanic Garden* was published and it seems that Blake engraved 'The Fertilization of Egypt' and the Portland Vase plates on a reduced scale for this.

On August 29 Blake told Cumberland that he had been commissioned to do fifty small pictures of Biblical subjects, for an unnamed patron, identifiable as Thomas Butts, at the price of £1 1s each. This must have seemed trivial to the man who, two years before, had hoped for so much from the *Night Thoughts*. Butts, a clerk in the office of the Commissary General of Musters, was not at the time a man of means but merely a friend of some years standing. The commission was accepted, as it was intended, as a gesture of generosity. Blake's pride, which was considerable, would not have allowed him to accept an offer of charity.

Toward the year's end, on December 14, Blake signed a receipt for Flaxman, for £8 8s for engraving three plates, and 12s 6d for the copperplates. The engravings were for the sculptor's *A Letter to the Committee for Raising The Naval Pillar*. **1800** Blake exhibited a tempera at the Royal Academy, 'The loaves and fishes'.

Although William Hayley, who 'wrote epitaphs upon his dearest friends before their eyes were well closed', must have known of Blake since 1784, it was not until this year that the two men became almost comically entangled. Flaxman, who never seems to have wavered in his efforts on Blake's behalf, suggested him as the engraver of the plates for Hayley's *An Essay on Sculpture*. The delays in making the plates were probably due to Blake working on his drawings for Butts. Still, the correspondence between the verbose versifier and the artist was most amicable. Following an exchange of letters between Flaxman and Hayley, the latter announced on July 22 that Blake had 'taken a cottage in this little marine village [Felpham, Sussex] to pursue his art in its various Branches under my auspices'.

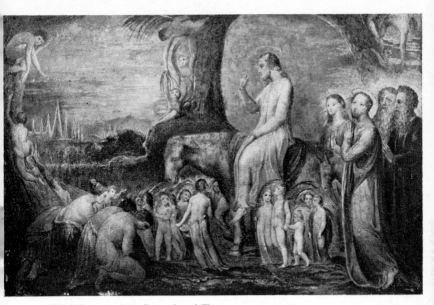

'Christ's entry into Jerusalem.' Tempera on copper
12¼ × 18⅞ ins *Stirling Maxwell Collection, Pollock House, Glasgow Museums and Art Galleries*

After various delays, Blake, his wife and his sister (yet another Catherine about whom practically nothing is known) moved, on September 18, to Felpham with sixteen boxes and portfolios. The trip took from seven in the morning until eleven-thirty at night, but did not prevent Blake's starting work the next day.

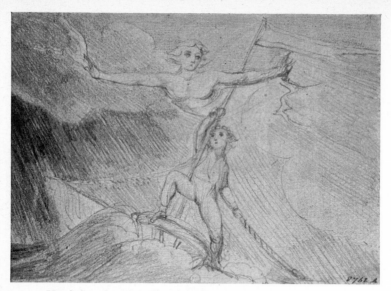

Headpiece for *Little Tom the Sailor*. Pencil drawing
$4\frac{5}{8} \times 6\frac{1}{2}$ ins *Victoria and Albert Museum*

Three days later Hayley wrote a ballad, *Little Tom the Sailor*, and Blake produced it from three plates. The text was done on copper, as in the 'Illuminated Books', while the head and tail-pieces are examples of his woodcutting on pewter. Although Hayley stated that the sale of the ballad helped to 'relieve the necessities' of the mother of the hero, only about eight copies have survived, some of them touched-up with wash or watercolor.

The major and immediate work seems to have been the painting, in tempera on canvas, of eighteen 'Heads of the Poets' for the library of Hayley's Marine Turret, which he had started building in 1797. This was a long narrow room with eight heads on either side and two on the wall facing the fireplace. They were executed in an extremely light tempera compared with others of the period, as restoration is beginning to show.

An engraving of John Caspar Lavater, after an unknown artist, was published by Joseph Johnson. It is a fine example of Blake's dot-and-lozenge technique as an engraver. The original drawing is now in Princeton University Library.

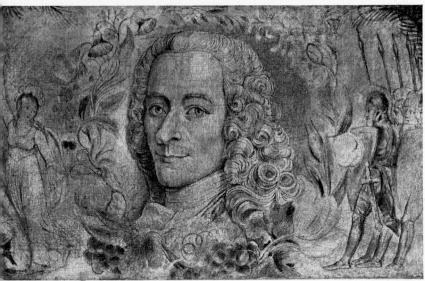

'Heads of the Poets.'
Voltaire
Tempera on canvas
$16\frac{1}{2} \times 17\frac{3}{4}$ ins
*Manchester City
Art Gallery*

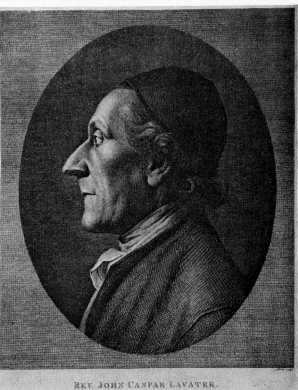

'John Caspar
Lavater.' Engraving
after an unknown
artist
$14\frac{5}{8} \times 11\frac{3}{4}$ ins
Sir Geoffrey Keynes

REV. JOHN CASPAR LAVATER.

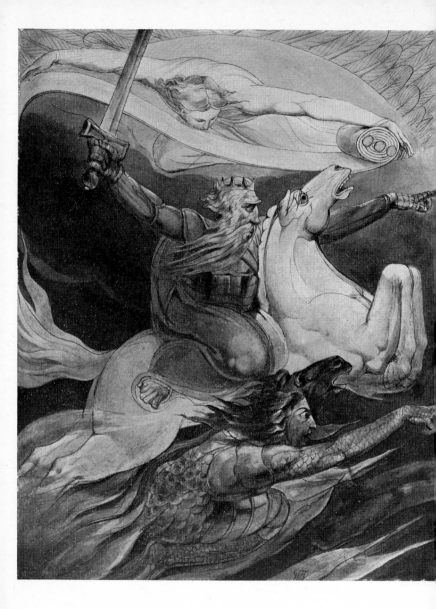

'Death on a Pale Horse'
15½ × 12¼ ins *Fitzwilliam Museum, Cambridge*

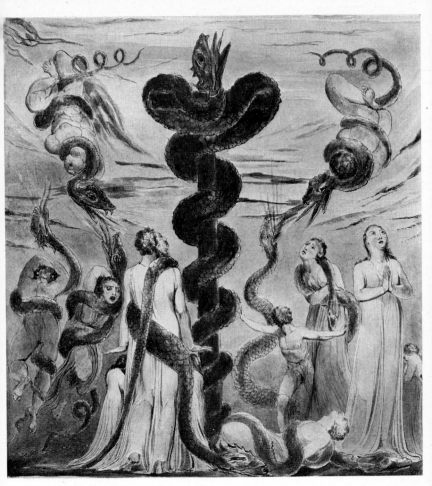

'The Brazen Serpent.' Watercolor
$13\frac{3}{8} \times 12\frac{13}{16}$ ins *The Boston Museum of Fine Arts*

The memorable series of letters to Thomas Butts started in
this year; in these Blake manages to make both his actual world
and his inner private vision an unsurpassable reality. Work, as
usual, seems to have continued on the drawings which Butts
had commissioned.

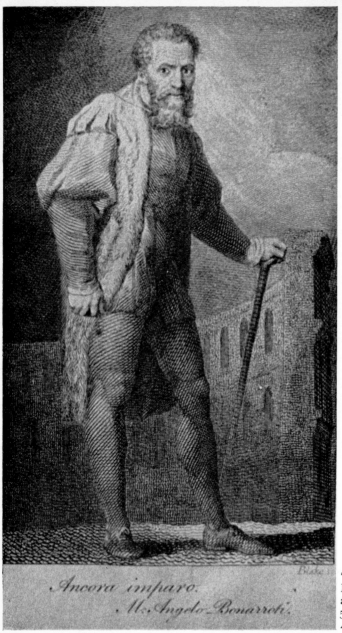

Ancora imparo.
M. Angelo Bonarroti.

'Portrait of
Michelangelo',
after Fuseli
$5\frac{7}{16} \times 3\frac{1}{16}$ ins
Author's collection

1801 Perhaps the worst of Hayley's faults was his persistence in displaying good intentions. It is likely, too, that he considered himself something of an authority upon various forms of insanity. He had been close to both George Romney and William Cowper and even, at this time, seems to have owned the MS of Christopher Smart's *Jubilate Agno*, written in Bedlam between 1756 and 1763. Although Blake clearly displayed his efficiency under difficult circumstances in the long series of letters written to Hayley after he had returned to London, it is equally obvious that the amiable poetaster considered the artist to be both eccentric and feckless.

His therapeutic solution for the latter failing was the suggestion that Blake should become a painter of miniatures. There was a fashion for such knick-knacks, and much of the output deserves no better description. Blake was adroit enough, as can be seen from the half-dozen or so characterless works identified as being done by him, such as the quite pleasing William Cowper after George Romney.

Although, in a letter to Butts, Blake may have declared his devotion to this new form of hack-work, in truth he had no heart for it. Payments may have seemed reasonable enough, but owing to his training it is clear that if he really had to do pedestrian pot-boiling, he would rather do it in his own way, engraving upon copperplates.

His only book illustration of the year, for Fuseli's *Lectures on Painting*, is one of the better examples of this work. This can be explained both by his admiration for Fuseli, who made the original drawing, and adoration of the subject, Michelangelo.

He was still working on the drawings for Butts and the indefatigable Hayley could be relied upon to provide chores and annoyances. As a compensation he had free access to Hayley's admittedly excellent library. There, surrounded with books by Cowper and Milton, he may have brooded upon the collapse of the edition which Fuseli was to have illustrated. Whatever the cause, he seems to have decided to illustrate Milton in his own fashion and in accordance with his own visions. It is not improbable that he hoped eventually to find a publisher who would commission him to engrave all the plates from all his own designs. This idea seems to have been short-lived, but he persisted in his drawing.

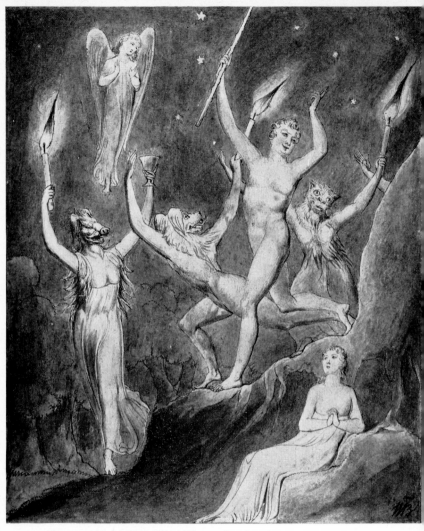

'Comus with his Revellers.' Watercolor drawing
$8\frac{9}{16} \times 7\frac{1}{8}$ ins *Huntington Library*

For his first series he chose *Comus*, a subject which had been
neglected by most other artists in favor of the more dramatic
Paradise Lost. He did two sets of eight drawings. One set,
which later was bought by Butts, is in the Museum of Fine

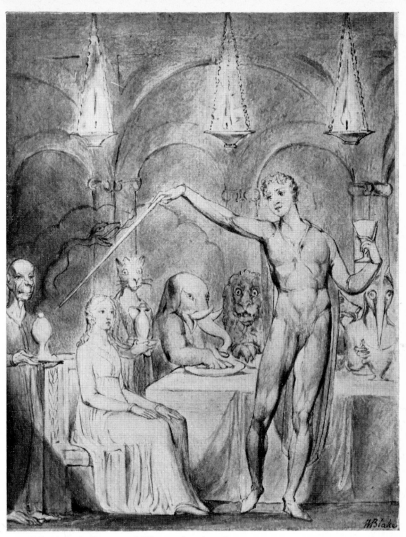

'The Magic Banquet.' Watercolor drawing
$5\frac{9}{10} \times 4\frac{3}{4}$ ins *Boston Museum of Fine Arts*

Arts, Boston. The other, in the Huntington Library and Art Gallery, may, according to a letter Blake wrote to Flaxman, have been commissioned by the Rev. Joseph Thomas of Epsom. The series was certainly in progress in October. Thomas,

'Adam naming the Beasts.' Engraving
$4\frac{5}{8} \times 4\frac{9}{16}$ ins *British Museum*

about whom very little was known until the researches of Leslie Parris were published, was yet another personal patron whom the faithful Flaxman transformed into a patron of Blake as well. **1802** The persistent Hayley produced a series of pedestrian ballads with two benevolent aims. One of these was the encouragement of Blake as designer and engraver and the other the promotion of a Chichester printer, Joseph Seagrave. The ballads were issued in four parts, for which Blake made fourteen engravings. Each part sold for 2s 6d. Blake, who not only engraved but also printed all the plates with the help of

MOTTO ON A CLOCK.

With a Translation by the Editor.

QUÆ lenta accedit, quam velox præterit hora !
Ut capias, patiens esto, sed esto vigil !

Slow comes the hour: its passing speed how great !
Waiting to seize it—vigilantly wait !

'The Peasant's Nest'
9 × 6⅝ ins *Thomas Minnick*

his wife, finally lost money on the deal. Seagrave's printing, however, showed that he could equal the work of most of his more celebrated London contemporaries.

At the same time, work proceeded on the engraving of the six plates for Hayley's *The Life and Posthumous Writings of William Cowper*. Although copies were distributed to intimates of the author in December, the book was not officially published until the following year. Blake himself designed and engraved the charming, if slightly absurd, 'The Peasant's Nest. Cowper's Tame Hares'.

1803 Although it must have been obvious to everyone except Blake and probably Hayley, who did not have to worry about such matters, that the *Designs to A series of Ballads* could never become a financial success, Blake still retained expectations. He even thought that he had discovered the secret of publishing and was astonished that he had not realized before that he could have made a fortune at it. In the meanwhile it was possible that some 115 copies were sold around that particular area of Sussex and that even less were disposed of by the London booksellers among whom the copies had been distributed in the most haphazard way.

Still, Hayley kept on producing hack-work such as the engraving of six plates after Maria Flaxman (half-sister to the sculptor), for the thirteenth edition of Hayley's *The Triumphs of Temper*. Neither the artist nor the engraver seems to have been stimulated by the astonishingly successful but tepid poem. The £63 which Blake received from the publishers, Cadell and Davies, was undoubtedly useful, although Hayley stated that neither side was satisfied by the deal.

Further, there was some disagreement about the size of the payments made by Hayley himself. It would seem that Blake was paid £31 10s for the head of Cowper, after G. Romney, in the earlier book; he now wanted £42 for a similar head of Romney, and £31 10s for a medallion.

On August 12 Blake became involved with a drunken soldier called Scolfield who, according to a letter to Thomas Butts, 'threaten'd to knock out my eyes ... it affronted my silly pride. I therefore took him by the elbows and pushed him before me till I had got him out' of the garden. As a petty revenge the soldier laid a charge of sedition, claiming that Blake had damned the King and made other offensive remarks. Such an accusation was a serious matter at that moment.

On July 8 and August 20, Blake delivered eleven drawings to Butts for which he received £14 14s. These seem to have completed or almost so the fifty which he had been commissioned to draw. Among them was 'The Three Maries' which he had started working on in October 1800 and had not finished by November 1802.

In September the Blakes moved back to London, settling

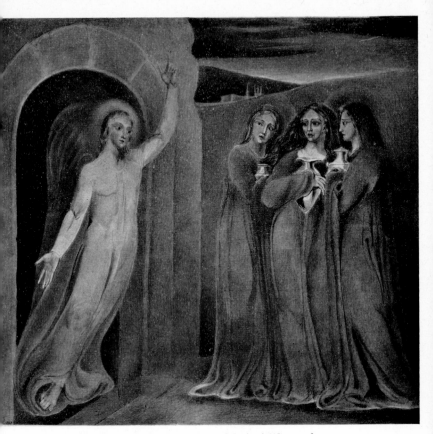

'The Angel appearing to The Three Maries.' Watercolor
14 9/16 × 15 15/16 ins *Fitzwilliam Museum, Cambridge*

down at 17 South Molton Street, just south of Oxford Street.
Here he seems to have occupied the first floor up. It is not
known whether the ground floor was then used commercially
as it has been for at least a century.

Suffering as he had been from seeing no pictures except
those belonging to Hayley and his friends, Blake was over-
come when, in October, he visited the Truchsessian Picture
Gallery. This consisted of a large collection belonging to Count
Joseph Truchsess shown near Oxford Street. Although it is

highly doubtful whether any one of the pictures had ever been seen by the painter to whom it was attributed by the Count, who had a penchant for only the most famous, it is more than likely that there were a considerable number, better described as 'School of' So-and-So. To a visually starved man such as Blake was at that time these and the sheer number of pictures shown must have appeared a veritable heaven.

Prince Hoare, Secretary for Foreign Correspondence at the Royal Academy, wrote to Flaxman about a newly discovered bust of Ceres and the sculptor replied with a description and two sketches. Hoare then asked if he could have them engraved and Flaxman agreed, recommending Blake for the job. The two views appeared in outline engraving in Hoare's *Academic Correspondence*, 1803, published in 1804. The relationship between Hoare and Blake seems to have been excellent and when the former's *An Inquiry into the Requisite Cultivation and Present State of the Arts of Design in England* was published in 1806 the only plate, a frontispiece, was rather surprisingly engraved by Blake after Sir Joshua Reynolds's 'The Graphic Muse'.

Although the plate is dated March 25, 1799, John and Josiah Boydell only completed their edition of *The Dramatic Works of Shakespeare* in this year. Blake's contribution to Vol. IX was an engraving after John Opie, illustrating 'Romeo and Juliet, Act IV'. The hundred plates were issued without text and probably about the same time under the title of *Boydell's Graphic Illustrations of the Dramatic Works of Shakespeare*.

1804 January 11, Blake appeared before the magistrates at the Guildhall in Chichester to face the charge of sedition and was acquitted. The magistrates were convinced by Blake's counsel that he was innocent of damning the King, all his subjects, his soldiers, as 'all slaves' and declaring that when Bonaparte came he would help him.

Unwittingly, Blake now found himself in the position of being Hayley's London agent. This must have interfered with the time of a man who still had hopes of establishing himself where he thought he belonged among the leading engravers of book illustrations in England. Had Blake achieved proper employment he would have enjoyed financial security and, since the engraving of a plate is a less lengthy business than the

'Shipwreck' from Hayley *The Life of George Romney*
$5\frac{1}{16} \times 7\frac{1}{16}$ ins *Thomas Minnick*

uninformed might suppose, the time in which to develop his
own grand projects. One of these which was to occupy him
for the next four years was the writing and etching of *Milton*,
and the starting of the even larger *Jerusalem*.

With all this pressing upon him, he was dilatory in deliver-
ing the only plate he was to do for the *Romney*. He had expected
to be commissioned to do several, and had been fobbed off
with 'The Shipwreck'. This is not a satisfactory plate; Blake
seems to have tried to satisfy all those who had criticized his
engraving when he was in Sussex.

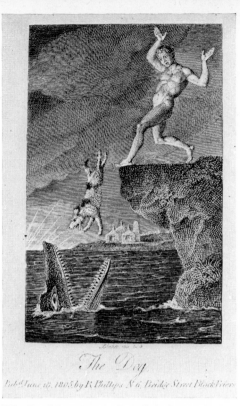

The Dog

Pub.^d June 18. 1805 by R. Phillips N.^o 6. Bridge Street Black Friars

'The Dog' from Hayley's *Ballads*. Engraving
6½ × 5½ ins *Princeton University Library*

Flaxman was still doing what he could and asked Blake to make three outline engravings for a new edition of his illustrations of *The Iliad of Homer*, 1805. Longmans, Hurst, Rees & Orme paid £5 5s for each of these.

He made two plates after another old and true friend, Fuseli, of 'King Henry VIII, Act IV. Sc. II' and 'Romeo and Juliet, Act I [*sic* for v]. Sc. I' for Alexander Chalmers's edition of *Shakespeare*, 1805. He received £26 5s apiece for them.

For a moment it may have seemed that, even without employment by Hayley, he was again becoming established.

1805 One result of Blake's efforts on behalf of Hayley was a relationship with the bookseller and publisher, Richard Phillips. On January 22 he reported that Phillips was willing

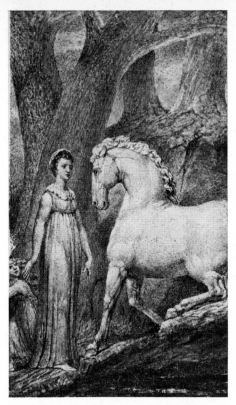

'The Horse.' Tempera on gesso priming, copper plate
$4\frac{1}{2} \times 2\frac{3}{4}$ ins *Mr and Mrs Paul Mellon*

to publish the *Ballads*, extended from the 1802 failure, with six or seven plates. The volume was to be the same size as *The Triumphs of Temper*, and to be printed by Hayley's prize printer, Joseph Seagrave of Chichester.

By April 25 it had been settled that the number of plates was to be five 'as highly finish'd as I can do them'. The subjects were chosen: 'The Dog', 'The Eagle', 'The Lion', 'The Hermit's Dog' and 'The Horse'. On June 4 Blake wrote to Hayley expressing fear that 'The Horse' was going to be omitted, saying he considered it one of his best. His affection for this plate and his treatment of the subject is shown by the charming little tempera of it on gesso-coated copper. Its size is so close to that of the engraving as to suggest that the experi-

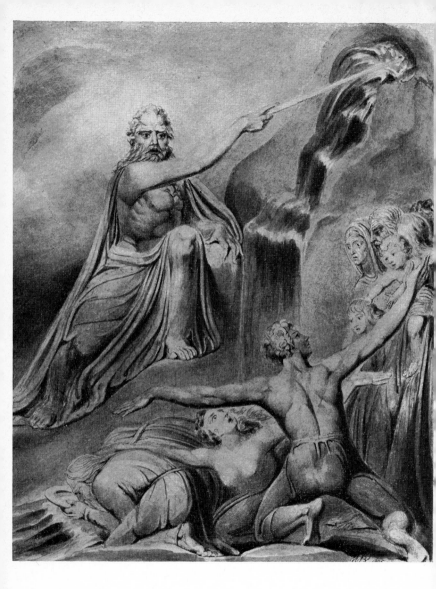

'Moses Striking the Rock.' Watercolor
14 × 11⅝ ins *Mrs William Tonner*

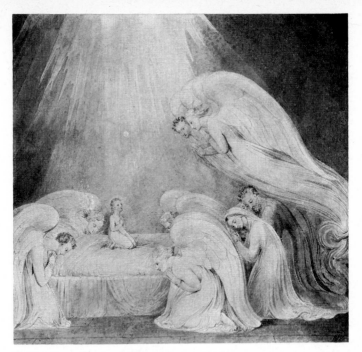

'Infant Jesus Praying.' Watercolor
12½ × 13½ ins *Houghton Library, Harvard University*

mental Blake may well have tried the effect of placing a hot, freshly-inked plate upon still unset gesso. That this would produce a perfect print on the gesso has been proved by those who have worked with S.W.Hayter in Atelier 17.

Blake received £52 10s from Phillips for the five engravings, but the letter to Hayley had mentioned another equal sum to follow without indicating its source. As Hayley, in a burst of generosity, had presented the book to Blake, he could hardly have been expected to pay. It can only be conjectured that it was supposed to come from the profits which never materialized.

Blake did a lot of watercolors for Butts in this year and also sold him, at £1 1s each, eight of the 'Colour Printed Drawings'. It is possible that two of the temperas shown in his Exhibition of 1809, were done at this time: 'The Spiritual Form of Nelson guiding Leviathan' and 'The Spiritual Form of Pitt guiding Behemoth'. The latter bears the date 1805.

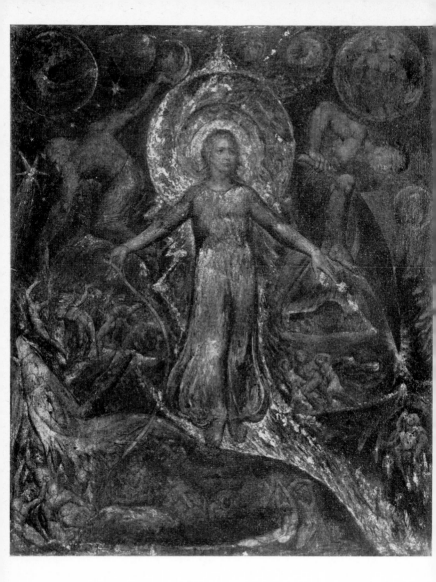

'The Spiritual Form of Pitt guiding Behemoth.' Tempera
$29\frac{1}{8} \times 24\frac{3}{4}$ ins *Tate Gallery*

Detail from 'The Spiritual Form of Pitt guiding Behemoth'.
Tate Gallery

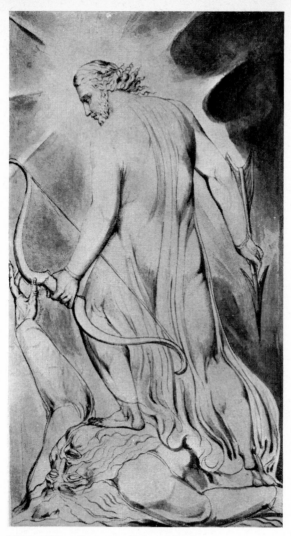

'Christ Trampling upon Urizen.' Sepia
9¼ × 5¼ ins *National Museum of Wales*

On Christmas Day, Butts engaged Blake to teach his son at
an annual fee of £26 5s. Thomas Butts junior does not seem to
have been an assiduous pupil, and legend has it that the father
profited more from the lessons than the son. An example of

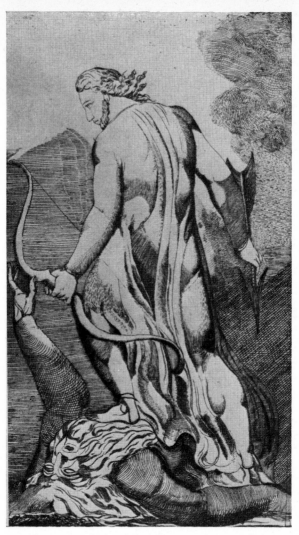

'Christ Trampling upon Urizen' by Thomas Butts after Blake. Engraving $9\frac{1}{2} \times 5\frac{7}{8}$ ins *University of Glasgow*

the work of one of them, possibly dating from the next year, is the engraving known as 'Christ Trampling upon Urizen', which can be compared with Blake's original drawing of the same subject.

'A Widow Embracing the Turf.' Drawing
$9\frac{3}{4} \times 13$ ins *Gwen Lady Melchett*

Before October, Blake was engaged by Robert Hartley Cromek to make a series of forty drawings in illustration of Robert Blair's *The Grave*. Cromek's declared intention was to choose twenty of these which were to be engraved by the artist. It is probable that Blake never completed forty drawings. One, picked out by Flaxman, along with three others, as particularly 'Striking' was 'A widow embracing the turf which covers her husband's grave'.

Flaxman believed, and Blake himself made it clear in a letter to Hayley of November 27, that the understanding was that he was to engrave his own designs. The letter was given to Cromek to forward to Hayley, but when doing so Cromek enclosed with it a single sheet prospectus, written by himself. This announced that the new edition would be 'illustrated with Twelve Very Spirited Engravings by Louis Schiavonetti, from Designs Invented by William Blake'. The arrival of Blake's letter along with Cromek's contradictory prospectus must have puzzled Hayley. In the meantime, Blake, certain

of employment, made a relief etching of 'Death's Door'. Undoubtedly the rugged appearance of the relief etching must have shocked the conventional Cromek, but his behavior cannot be excused. The slick tidiness of Schiavonetti's version, as finally used in the book, makes a poor ghost when compared with the vigor of Blake's own interpretation of his subject.

By the end of the year, when Cromek was engraving the frontispiece Blake had designed for Benjamin Heath Malkin, and even Flaxman seemed to have turned against him, things must have looked black.

1806 Despite what may have seemed treachery in allowing Cromek to engrave the frontispiece for *A Father's Memoirs of His Child* Blake does not seem to have felt any bitterness toward Malkin. Like Richard Edwards in 1797 he escapes the barbed epigrams in the pages of Blake's *Notebook*.

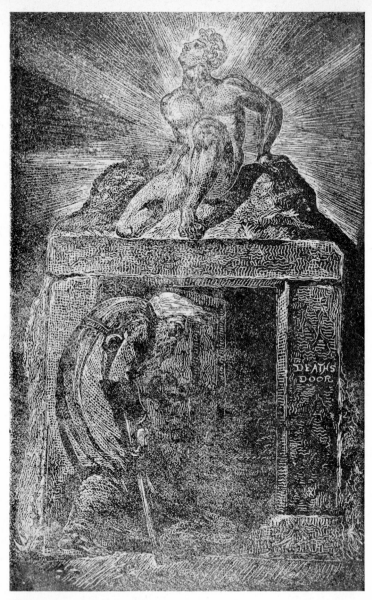

'Death's Door.' Relief etching
6¼ × 4½ ins *Coll. late A.H.Palmer* (Photo Victoria and Albert Museum)

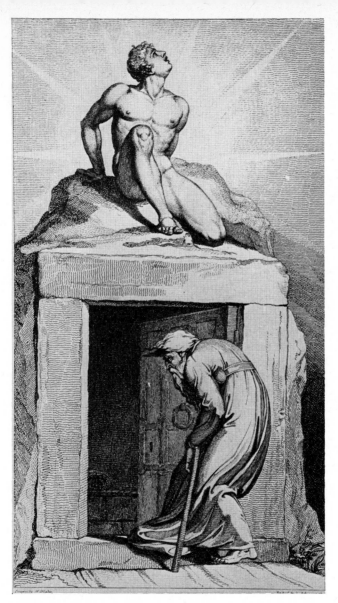

'Death's Door' by Schiavonetti after Blake. Engraving
$11\frac{5}{8} \times 6\frac{5}{8}$ ins *Author's collection*

Malkin gives the only accurate account of Blake to be published during his lifetime. Most of the information must have come from Blake himself although it is possible that some was supplied by George Cumberland, since Malkin dedicated the book to Thomas Johnes of Hafod and George Cumberland, in 1796, wrote *An Attempt to Describe Hafod*, illustrated with a map engraved by Blake.

Since Malkin's introduction, in the form of a prefatory letter to Johnes, is dated January 4, 1806, and gives no hint of any rift between himself and Blake, it might have been that Blake, then thinking he was going to be fully occupied with *The Grave*, himself suggested that the competent if uninspired Cromek should engrave the frontispiece.

Although Blake felt that he had been damaged artistically by being rejected as engraver in favor of Schiavonetti, he did not quite cut himself off from the project of *The Grave*. Through his friend Ozias Humphry he managed to get permission to dedicate the book to the Queen, Charlotte, which he did in a poem. It seems that Cromek had hoped to publish the book in the spring of this year but failed to get enough subscriptions. The rejected design for a title-page bearing the date 1806 but probably done the year before seems to support the idea that publication was being delayed.

Cut off from participation in the production of *The Grave* Blake went ahead with another idea, the publication of an engraving of 'The Canterbury Pilgrims'. The accepted story is that Cromek saw Blake's preliminary drawing for the plate at South Molton Street and promptly went round to commission a drawing, for engraving by Schiavonetti, from Thomas Stothard. Probably Stothard knew nothing of Blake's project until he was advanced in his own painting and the commitment that went with it. The result was an irreparable breach between the erstwhile friends. Blake on this occasion, besides making epigrams in the *Notebook*, may also have been publicly vociferous about Stothard's supposed treachery.

The Rev. Joseph Thomas, who by now had acquired in addition to the *Comus* drawings a copy of *Songs of Innocence and of Experience*, again appears as a patron. He owned a second folio, 1632, Shakespeare which he decided to extra-illustrate. Among the thirty-seven drawings added to the volume, along

Rejected title page for *The Grave*
8 × 9½ ins *Huntington Library and Art Gallery*

'Enoch' Lithograph
8⅝ × 12 3/16 ins *British Museum*

with works by Sir Robert Ker Porter and William Mulready,
were six by Blake, executed between this year and 1809.
These are 'Jaques and the Wounded Stag' 1806, 'Richard III
and the Ghosts' n.d., 'Queen Katharine's Vision' 1809,
'Brutus and the Ghost of Caesar' 1806, 'Hamlet and his
Father's Ghost' 1806, and 'An Angel Vaulting from a Cloud'
1809.

While Butts continued as Blake's main patron, the fact that
Flaxman bought a drawing in November for £1 1s suggests
that any coolness had evaporated. It has been suggested that
the drawing might have been 'The Last Judgment' which
was sold after the sculptor's death, at Christie's on 1 July,
1828.

1807 Aloys Senefelder invented lithography in 1796. He
patented the new process in 1800, when his brother's partner,
P.André, arrived in London to display it. In 1803 he published
a selection of six *Specimens of Polyautographs* by various artists.
This was reissued in 1806 in five parts containing extra prints,
including one by Fuseli, and Blake's only lithograph 'Enoch'
was presumably intended for a sixth fascicle.

'An Angel Vaulting from a Cloud' Watercolor
$9\frac{1}{8} \times 6\frac{13}{16}$ ins *British Museum*

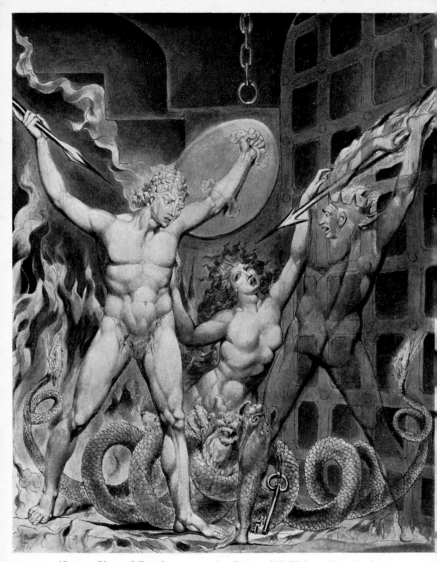

'Satan, Sin and Death come to the Gates of Hell' from *Paradise Lost*
19½ × 15¹³⁄₁₆ ins *Huntington Library and Art Gallery*

OPPOSITE
'Adam and Eve in Paradise Watched by Satan' from *Paradise Lost*
10½ × 7⅞ ins *Fogg Art Museum, Harvard University*

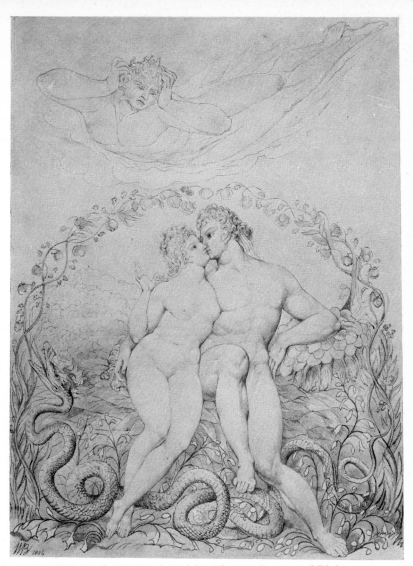

Work as always continued for Thomas Butts, and Blake was still being paid to teach the younger Butts.

In the Milton project Blake tackled the matter of *Paradise Lost*. There are two series of the drawings, as well as a number of related drawings and variations upon them.

A large watercolor of 'The Last Judgment' was commissioned by the 'Countess' of Egremont, through the good offices of Ozias Humphry. The other large watercolor of 'The Last Judgment' now in the Stirling Maxwell Collection differs in many ways from the Petworth watercolor. It, too, contains a myriad of figures, but they are arranged in different formations and groupings and the design is more open and the handling lighter.

In May, Cromek received a request for £4 4s from Blake for a drawing, now in the British Museum Print Room, designed to accompany his dedicatory poem *To the Queen*. In return Cromek wrote an offensive letter which displays his character to the full.

As a man of rather inflexible pride, Blake's reaction was, even in poverty, to go his own way, working in his own techniques. It has to be admitted that since he must have known Cromek's taste he could hardly have thought that the money-grubbing entrepreneur would have issued an expensive and lavishly printed book with twenty illustrations done in the highly personal manner and individual technique shown in the relief etching of 'Death's Door'. Although Cromek's behavior cannot be justified it is possible that Blake, refusing to work in a style which would be acceptable to the public for whom it was intended, may have been more blameworthy than has usually been admitted.

Thomas Phillips's portrait of Blake which was engraved as the frontispiece to *The Grave* was exhibited at the Royal Academy. It is now in the National Portrait Gallery. A more immediate version belongs to Mr Philip Hofer.

1808 In January and February Blake wrote three accounts

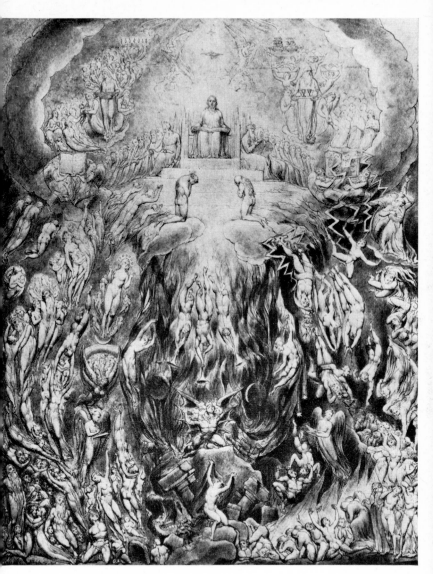

'A Vision of the Last Judgment.' Pen and wash touched with red
19¼ × 15⅛ ins *Stirling Maxwell Collection, Pollock House, Glasgow Museum
and Art Galleries*

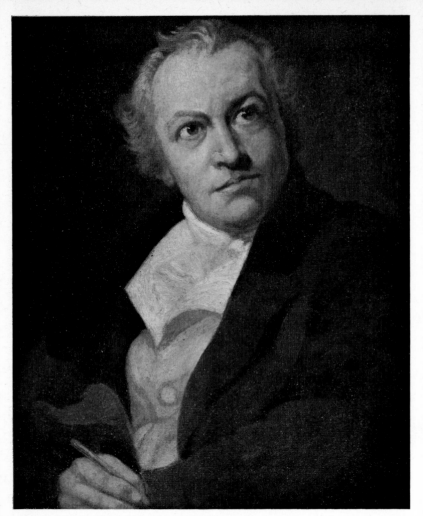

'William Blake' by Thomas Phillips RA
Philip Hofer, Houghton Library, Harvard University

which vary in detail of his watercolor of 'The Last Judgment'
for Ozias Humphry who was going blind.

After a lapse of eight years, Blake again exhibited at the
Royal Academy, showing two watercolours, 'Jacob's Dream'
and 'Christ in the Sepulchre'.

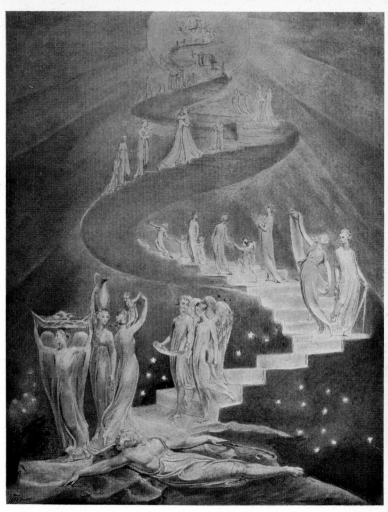

'Jacob's Dream.' Watercolor
$14\frac{5}{8} \times 11\frac{1}{2}$ ins *British Museum*

ON PAGES 88/89

Detail from 'A Vision of the Last Judgment.' Watercolor
$19\frac{7}{8} \times 15\frac{3}{4}$ ins *Petworth House, National Trust*

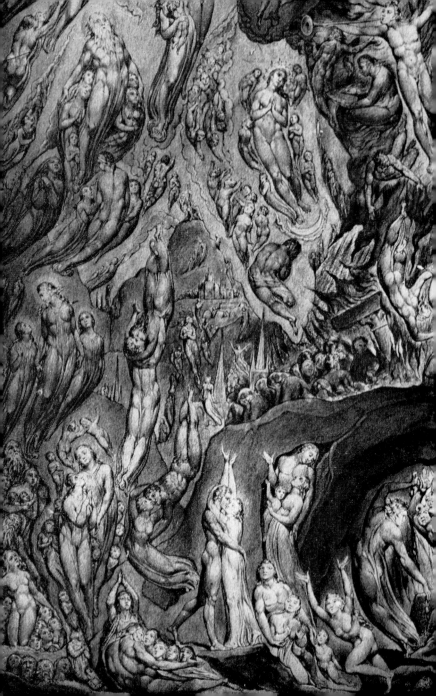

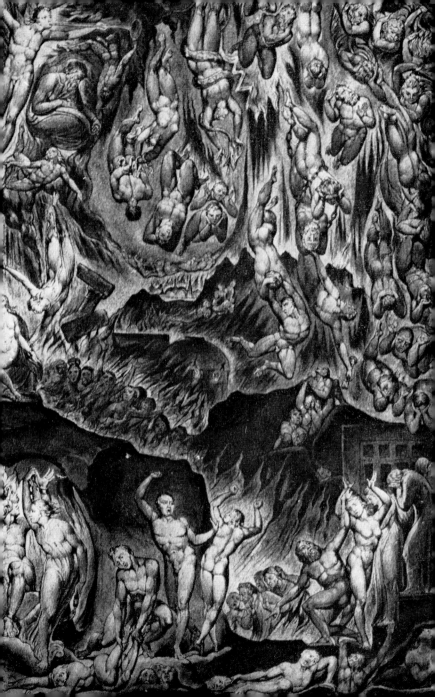

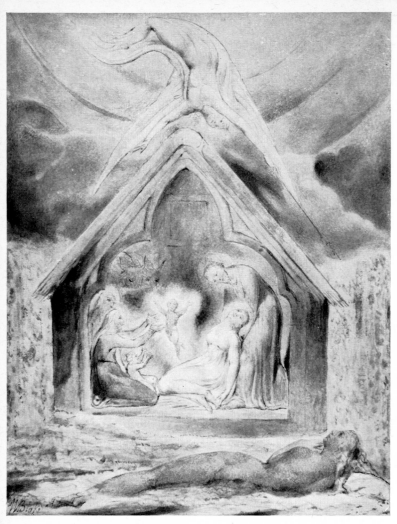

'The Descent of Peace' from Milton *On the Morning of Christ's
Nativity*. Watercolor drawing
$6\frac{5}{16} \times 5$ ins *Huntington Library and Art Gallery*

The two sets of six illustrations for Milton's *On the Morning
of Christ's Nativity* seem to have been done about this date; as
was the watercolor 'Epitome of James Hervey's Meditations

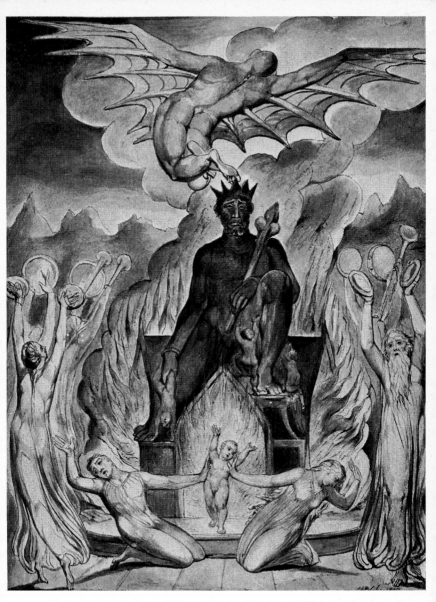

'Sullen Moloch' from Milton *On the Morning of Christ's Nativity.*
Pen and ink, grey and sepia washes and watercolor over faint pencil
$10\frac{1}{8} \times 7\frac{3}{4}$ ins *Whitworth Art Gallery, Manchester*

among the Tombs'. This is an elaborate work in which Blake has identified each figure with an inscription. It bears a distinct relationship to the Petworth 'The Last Judgment' and to some of the designs for *The Grave*.

The Grave was finally published in July. Cromek, probably an astute salesman, had delayed long enough to collect sufficient subscriptions to pay both Schiavonetti and T.Bensley, for his rather distinguished printing. The nudity of the figures disturbed the sensibilities of some who examined the book. Robert Hunt made a mock of it in the *Examiner* of August 28, while his brother Leigh in the same issue enrolled Blake as an Officer of Painting in 'The Ancient and Redoubtable Institution of Quacks'. However, William Paulet Carey, in a pamphlet on Stothard's painting, *A Critical Description of Chaucer's Pilgrims to Canterbury*, went out of his way to praise Cromek for 'having conceived the idea of employing that extraordinary Artist, *Blake*, to compose his *grand designs* for *Blair's Grave*'. It is likely that Blake started his annotations upon his copy of *The Works of Sir Joshua Reynolds*, 1798, which contained some of his most acute observations upon art.

1809 During these last ten years Blake was out of favor with the publishers, although Butts continued as a patron and, as Leslie Parris has shown, he received considerable encouragement from the commissions of the Rev.Joseph Thomas.

Blake continued to paint in tempera, with which he never ceased to experiment, and while his watercolors were accepted by the Royal Academy these imaginative works in a strange and, to the Selection Committee, alien medium were beyond their powers of judgment. Fighting back, Blake decided to give his own Exhibition in the house of his older brother, James. This seems to have opened about the middle of May and, although it remained available well into the following year, was scheduled to close on September 29.

In connection with the Exhibition, and with his painting after Chaucer and the engraving, upon which he was already working, Blake had printed in ordinary type four advertising

'Epitome of Hervey's "Meditation among the Tombs".' Watercolor 17 × 11½ ins *Tate Gallery*

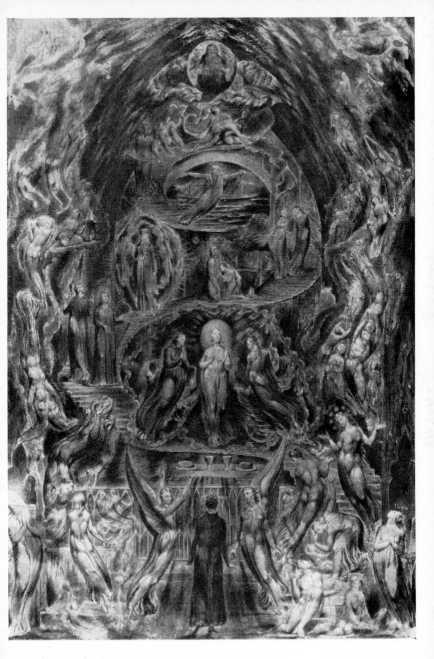

leaflets or handbills and a pamphlet. These are *Blake's Chaucer, The Canterbury Pilgrims. The Fresco Picture*, dated May 15, *Blake's Chaucer: An Original Engraving, Exhibition of Paintings in Fresco, A Descriptive Catalogue of Pictures* and *A Descriptive Catalogue of Blake's Exhibition*.

Although it is likely that considerably more paintings and drawings were available for the inspection of and possible purchase by visitors to the Exhibition, the index to the *Descriptive Catalogue of Pictures* lists sixteen items, for most of which Blake supplied a longer or shorter essay or note.

The only known review appeared in the *Examiner*, September 17, by Robert Hunt. This was the most virulent attack unleashed upon Blake during his lifetime and bears signs of some personal spite having replaced any normal critical acumen. Hunt seems to have visited the Exhibition but his diatribe, full of misquotations, deals mostly with the *Catalogue*.

Although the Exhibition was not a success, copies of *A Descriptive Catalogue* were circulated and achieved some reputation among the more sensitive and enquiring. George Cumberland's son, also George, wrote to his father, by then living in Bristol, about it and was ordered to send him two copies, with a third for a Bristol bookseller.

It was probably about this time that Blake had, for a short period, another pupil, William Seguier, later the first Keeper of the National Gallery where he established a reputation both for incompetence and for a passion for brown varnish, apparently agreeing with Sir George Beaumont, connoisseur and amateur artist, that a really good picture should have the color of a Cremona violin.

1810 In the spring the indefatigable diarist, Henry Crabb Robinson, seems to have become interested in Blake and visited the Exhibition on April 23, when he bought four copies of *A Descriptive Catalogue*. On June 10, he took Charles and Mary Lamb to see the pictures, and probably persuaded Robert Southey to visit it. Southey, unlike the young Seymour Kirkup who described the picture from memory for Swinburne in 1865, was not impressed by 'The Ancient Britons' but he states that Blake's information on the Welsh Triads could only have come from William Owen (later Pughe). This suggests that Blake, as seems likely from *Jerusalem*, knew the

Welsh Druidists and folklorists early in the century. The fact that elsewhere Southey says that Blake did not meet Owen Pughe until after the death of Joanna Southcott, 1814, merely shows that he was inaccurate. The subject of 'The Ancient Britons' was one which would have appealed to the Welsh scholars. Perhaps some day the picture will be found hanging in an obscure corner of some Welsh mansion.

All this time Crabb Robinson was assiduously collecting information on Blake for the only important account, apart from Malkin, to be written while he lived. Unfortunately from the point of view of Blake's immediate reputation, this appeared only in German, translated by Dr Nikolaus Heinrich Julius, in the first number of *Vaterlandisches Museum* in January 1811.

Although Blake may have started writing the essay on art and engraving in the *Notebook* earlier, most of what is called the *Public Address* was probably written in this year.

Another essay, later entitled *A Vision of the Last Judgment* by D.G.Rossetti, is subtitled 'For the Year 1810 Additions to Blakes Catalogue of Pictures &c'. Undoubtedly Blake had been interested in the subject of the Last Judgment all his life, but the drawing of it for *The Grave*, followed by the success of the more ambitious version now at Petworth had spurred him.

The painting with which the essay dealt was a much larger version in tempera. W.M.Rossetti says that it was about 7×5 ft and contained about a thousand figures. This picture, now lost, remained with Blake for the rest of his life and, according to J.T.Smith (who had known Blake from the days of *Poetical Sketches* and was to write on him after his death) 'The lights of this extraordinary performance have the appearance of silver and gold; but upon Mrs Blake's assuring me that there was no silver used, I found, upon a closer examination, that a blue wash had been passed over those parts of the gilding which receded, and the lights of the forward objects, which were also of gold, were heightened with a warm colour, to give the appearance of the two metals'. Another informant, possibly Samuel Palmer, said, however, that looking at the painting one day Blake explained, 'I spoiled that—made it darker; it was much finer, but a Frenchwoman here didn't like it'.

Two drawings possibly connected with the lost picture exist. One is in the National Gallery of Art: Rosenwald Collection, and the other, which belongs to Gregory Bateson, is on loan to the Honolulu Academy of Arts.

Blake published his engraving of 'The Canterbury Pilgrims' on October 8. One copy of the first state bears the pencil inscription, 'This print was coloured by the artist, W.Blake and given by Mrs Blake to F.Tatham, Esq'. Other colored copies, of both the first and second states, have been found.

Louis Schiavonetti died on June 7 and Cromek found trouble in having Stothard's print completed. Following the death of Cromek himself in 1812, his widow sold the plates and copyright of *The Grave*, in 1813, to Rudolph Ackermann in order to finish the job. In spite of these delays and changes in engravers Stothard's rather insipid interpretation of the subject proved vastly more popular than that of the originator of the idea, and early states of Blake's plate are of considerable rarity. The copperplate, however, has survived.

Although there are mentions of other minor financial dealings over the years, the last payment to Blake from Thomas Butts, his only really consistent patron, for which any document has been traced, is dated December 18. It is certain that many of the Blake–Butts accounts have not survived or been traced, but the records of the ten years that do, show that Butts paid Blake £420 18s 6d. This does not average out at any large sum per annum, but it will be remembered that, as recently as 1770, Oliver Goldsmith's preacher, in *The Deserted Village*, was 'passing rich with forty pounds a year'. The style of life of William and Catherine Blake has never been described as ostentatious. If not consistently, Butts continued to buy from Blake for many years, as the histories of individual pictures show.

Blake lived a very withdrawn life for the next eight years. It is certain that he was engaged with the hundred plates of *Jerusalem* and that he was also coloring copies of his other 'Illuminated Books', including the fifty superb plates in the copy of *Milton* in the Library of Congress: Rosenwald Collection, of which three pages are watermarked with the date 1815.

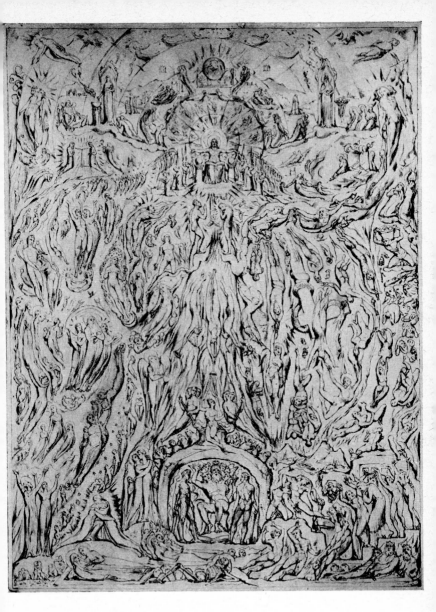

'A Vision of The Last Judgment.' Pencil, wash, india ink
$17\frac{7}{8} \times 15\frac{5}{8}$ ins *National Gallery of Art, Washington, Rosenwald Collection*

1811 It is practically certain that the date on Blake's largest surviving painting reads '1811'. This is a tempera on canvas. It was apparently titled 'An Allegory of the Spiritual Condition of Man', by W.M.Rossetti in 1863. Various suggestions for the interpretation of the theme have been made. Unfortunately Blake did not provide identificational inscriptions as in the 'Hervey's Meditations', and it is possible that the picture may be based upon some devotional book not yet identified.

G.E.Bentley, Jr, has suggested that either Butts or Malkin may have edited and probably financed the pamphlet *The Prologue and Characters of Chaucer's Pilgrims . . . intended to illustrate A Particular Design of Mr. William Blake*, 1812. This has a frontispiece, dated December 26, 1811, showing a reduction of a part of the large engraving, of those passing the gate of the Tabard Inn. There is also a vignette of a Gothic Cathedral on p. 58.

1812 In his handbill, *Exhibition of Paintings in Fresco*, 1809, Blake had insisted that his temperas were 'all in Watercolours (that is in Fresco)' as opposed to the enemy oil-painting. Although he may have used a dilute glue as a medium rather than gum, with which watercolors tended to be mixed, he was literally correct. The surface of these temperas over the gesso ground was not watercolor as known to the selectors at the Royal Academy, nor was it 'painting', deserving greater prominence in the exhibitions. The temperas were therefore rejected, or, if a small one was accepted, it was shown in an unfavorable corner.

It is not known when Blake became a member of the Associated Painters in Water Colours—there were fourteen at this time—but in the fifth annual exhibition he showed four items which would have proved unacceptable to the older establishments. These were three of his temperas, 'The Canterbury Pilgrims', 'The Spiritual Form of Pitt' and 'The Spiritual Form of Nelson', with 'Detached Specimens of an original illuminated Poem, entitled "*Jerusalem the Emanation of the Giant Albion*" '.

A relief etching of 'The Chaining of Orc' bears on a rock to the right the faint inscription 'Type by / W Blake / 1812'. Its title is determined by a pencil sketch in the British Museum,

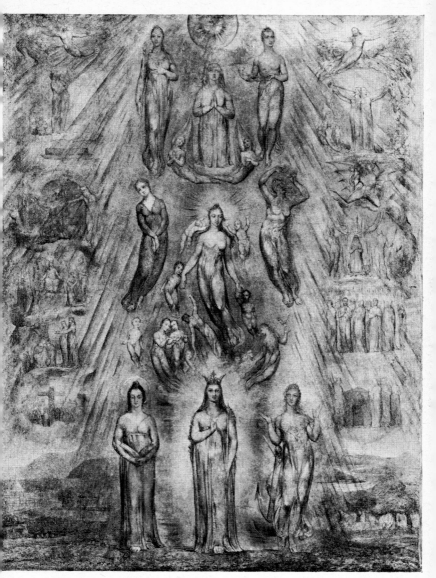

'An Allegory of the Spiritual Condition of Man.' Tempera on canvas
$59\frac{3}{8} \times 47\frac{3}{4}$ ins *Fitzwilliam Museum*

showing the subject in reverse, upon which Blake has inscribed the words.

1813 Blake was probably paid for his engraving of a portrait of the second 'Earl Spencer', after Thomas Phillips, although the plate was never published. The only known prints are in the British Museum Print Room, on paper with the watermark '1811'. The later date is established by George Cumberland who, on a visit to London, called on Blake on April 12 of this year and found him at work on the plate. They seem to have had some conversation on the subject of pewter, probably connected with Blake's own method of 'woodcutting' upon it.

1814 Flaxman, the brief upset of 1805 forgotten, remained faithful and anxious to help. He himself commissioned Blake to engrave thirty-seven outline engravings after drawings for Hesiod's *Works Days and Theogony*. The project was taken over by Longman, Hurst, Rees, Orme and Brown. Although the contract was not signed until February 24, 1816, and the book not published until 1817, payments to Blake started on September 22 of this year and continued until January 23, 1817, at the agreed price of £5 5s a plate. Altogether Blake received £194 5s.

1815 Young George Cumberland, with his brother Sydney, called on Blake on April 20, and next day reported by letter to his father that he had been shown the large painting of 'The Last Judgment' and that Blake 'has been labouring at it till it is nearly as black as your Hat—the only lights are those of a *Hellish Purple*—his time is now intirely taken up with Etching & Engraving'. It may have been later, after some unexpected sale of a drawing or painting, that Blake went to the expense of buying gold-leaf to rid himself of this color.

About this time, also, Blake in his experiments with tempera may have begun to solve the problems which had beset his earlier works, problems which were purely technical. Certainly the later 'frescos' are more fluid in their execution as if the medium was easier to control. The precision shown in the little tempera on copper, 'The Horse', suggests that, although the subject was earlier, his affection for it remained with him until he made the painting considerably later.

One suggestion, the result of experimentation, is that he replaced his earlier glue with a superior one, such as that

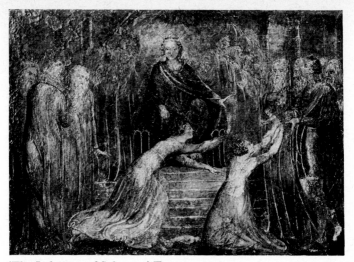

'The Judgment of Solomon.' Tempera on copper
10½ × 15 ins *Fitzwilliam Museum*

made from parchment scraps. This is extremely close to the
ordinary gelatin used in cooking, which, mixed in the right
proportions, mixes well with the powdered colors and handles
easily if the consistency is right.

The supports of most of the earlier pictures were not ideal.
Canvas, which alters according to the amount of humidity in
the air, needs to be properly supported and prepared with a
gesso of a superior quality than that which Blake was, pre-
sumably, using. Although any canvas upon which gesso has
been laid will crack if folded, a properly laid base will allow
of rolling in a large roll.

Blake had of course tried using copper as a support and it
seems to have been a favorite among painters of an experi-
mental turn of mind, such as George Stubbs. The major
difficulty in using it as a base for tempera is the difficulty of
making the gesso adhere to the metal. Then, too, it expands
and contracts as a reaction to heat or cold.

Graham Robertson, who bought much of his magnificent
collection directly from Captain Frederick Butts, the grandson
of Thomas, told me that the Captain was a difficult man to
deal with, usually to be found in bed in a darkened room
drinking gin and water. On every visit Graham Robertson
winced as he passed 'The Judgment of Solomon', knowing it

was painted on a copper plate. It hung in the hallway against a hotwater pipe, crackling merrily as the pipe cooled or heated. Persuading the Captain to let him have it took a considerable time and the thought of the increasing damage between the visits made each one slightly more painful. When he finally got it, in April 1906, it was in a sad condition. It had suffered from some early attempts at repair, and if these were the work of Thomas Butts, Jr, a likely candidate, they can only help prove that he benefited little from the lessons he was given by Blake. The 'composition resembling putty' which had been used was removed by Stanley Littlejohn and, using the small detail of the same subject in 'An Allegory of the Spiritual Condition of Man', Graham Robertson himself replaced the missing parts. It was finally given to the Fitzwilliam Museum and in 1965 flaking paint was reaffixed.

Although there can be no doubt that Blake was working with an energy which has seldom been equalled, the sheer problem of keeping alive and of obtaining the supplies he needed must have been formidable. Flaxman again helped out. As a young man he had made designs for the Wedgwood family, including a rather remarkable set of chessmen. He now involved Blake, by putting him in touch with Josiah Wedgwood, in the most pedestrian commercial venture of his life. This was the making of both the drawings and the engravings of domestic pottery for a catalogue designed only for use inside the firm at Etruria. Between the spring and December he, with Catherine called in to do a couple of the drawings, turned out 185 figures which were engraved on eighteen plates. The Wedgwoods seem to have been slow payers for the only transaction traced in their files records the payment to Blake of £30 for engraving on November 11, 1816. Undoubtedly he was paid more, probably as the work proceeded and he produced the drawings and then the engravings for approval.

Flaxman brought in other work as well, a commission to engrave seven plates for Abraham Rees's *The Cyclopaedia*, a work which appeared in seventy-nine fascicles between 1802 and 1820. The articles upon which Blake worked were 'Armour', 'Basso-Relievo', 'Miscellany [Gem Engraving]' and 'Sculpture'. In connection with this undertaking he revisited the

Wedgwood catalogue
$8\frac{5}{16} \times 6\frac{11}{16}$ ins *Sir Geoffrey Keynes* (Photo—Kerrison Preston)

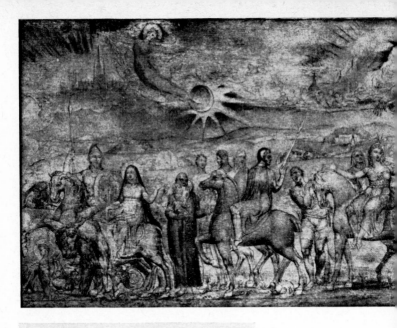

'The Laocoön'
ad vivum. Drawing
$12\frac{5}{8} \times 9$ ins
Henry J. Crocker
(Photo—
Kerrison Preston)

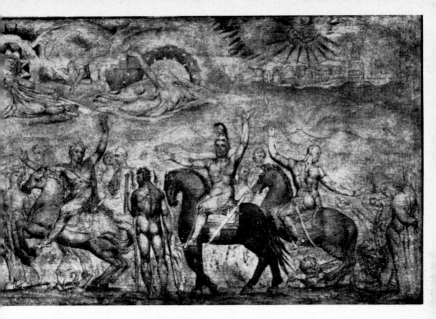

The 'Faerie Queen' from Spenser *The Faerie Queen.* Watercolor
Petworth House, National Trust

antique school at the Royal Academy to make a drawing of
the cast of the Laocoön. There he ran into Fuseli who cried,
'What! you here, Meesther Blake? We ought to come and
learn of you, not you of us!'.

The large watercolor of 'Spenser's Faerie Queen' now at
Petworth House may have been painted about this time al-
though it was not bought until 1828 when Lord Egremont
acquired it from Blake's widow for £84.

In the spring, it seems, Blake met a nineteen-year-old
engraver, William Ensom, who persuaded him to sit for a
pen-and-ink portrait. This was entered in the October 1814–
June 1815 session for the competition organized by the
Society for the Encouragement of Arts, Manufactures, and
Commerce. At the anniversary dinner held in the Freemason's
Tavern on May 30 Ensom was awarded the Society's silver
medal for the drawing. The artist died at the age of thirty-six
in 1832 and the drawing appeared at the sale of his effects
at Sotheby's but has not been traced further.

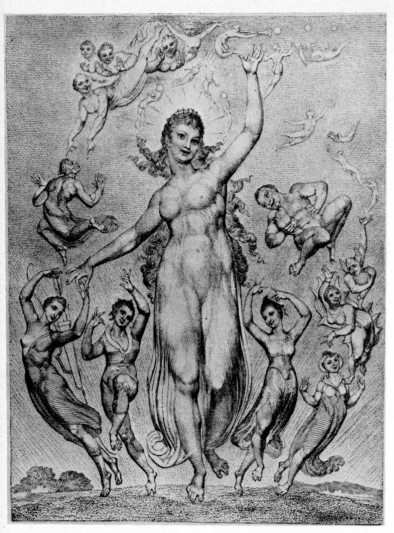

'Mirth and her Companions' from Milton *L'Allegro*. First state
$6\frac{3}{8} \times 4\frac{3}{4}$ ins *British Museum*

1816 Blake once again turned his attention to Milton and
engraved, largely in stipple with comparatively little line, the
first state of 'Mirth', from *L'Allegro*.

'Mirth' again appeared as the first illustration in a series of

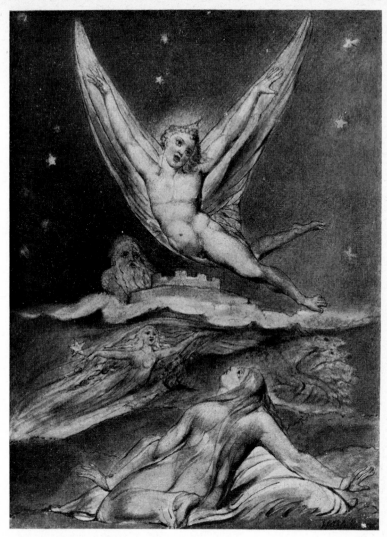

'The Lark' from Milton *L'Allegro*. Watercolor
$6\frac{3}{8} \times 4\frac{13}{16}$ ins *Pierpont Morgan Library*

six watercolors from *L'Allegro* which were accompanied by
another six from *Il Penseroso*. The paper being watermarked
1816 marks this as the earliest date upon which they could have
been painted.

From *Hesiod* after Flaxman. Engraving
Westminster Public Library

OPPOSITE
'The Judgment of Paris.'
$15\frac{1}{2} \times 18\frac{1}{2}$ ins *British Museum*

1817 John Flaxman's *Compositions from the Works Days and Theogony of Hesiod* finally appeared. Although fourteen of the plates are dated 1 November 1816 and the other twenty-four, including the title-page, 1 January 1817 the accounts of Longman and Company indicate that the label for the front-cover was not ready until 21 February.

It seems probable that this year marked Blake's determination to do a series of watercolors illustrating the Book of Job. Job had fascinated him almost all his life and one of his earliest engravings was 'The Complaint of Job' of about 1786. The series of twenty-one drawings, now in the Pierpont Morgan Library, was bought by Thomas Butts in what seems to have been the grand culmination of his career as a patron of Blake, although he continued as an intermittent patron and friend. As a climax to the formation of his collection this could not have been bettered. Butts does, however, depart from his favorite Biblical or Miltonic subjects, in falling for 'The Judgment of Paris' which is dated 1817 and which, in general

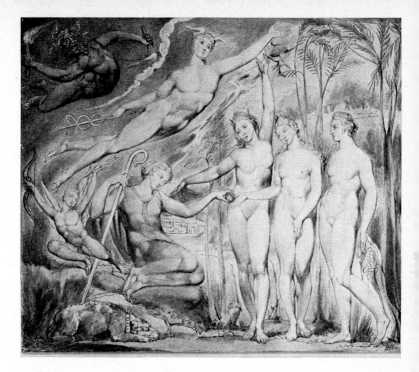

treatment, bears some resemblance to the illustrations for *Paradise Lost*. However, he was not tempted by the twelve watercolors of *Paradise Regained* with which Blake finished his various series of illustrations to the poems of John Milton.

1818 In the early summer young George Cumberland introduced John Linnell to Blake. Linnell promised to try to get him some work and on 24 June, he took round to Blake his drawing of 'James Upton, Pastor of the Baptist Church Meeting in Church Street, Blackfriars Road', as well as the copperplate for the proposed engraving. Between 12 August and 31 December, Blake received £17 10s for his work on the plate which was to be published on 1 June, although the only recorded copy was last seen about 1912. Probably Blake did far more of the work than Linnell allows in his fragmentary *Autobiography*, but he was not cheated.

Linnell was not then an experienced or proficient engraver, but he seems to have been a keen student of old prints and to have formed definite ideas about the parts of traditional

Epilogue to *For The Sexes:
The Gates of Paradise*.
Engraving $3\frac{3}{4} \times 2\frac{10}{16}$ ins

print-making which he considered still viable in the nineteenth century. He must have impressed his theories forcibly upon Blake brought up in the eighteenth-century tradition—which had plumbed the depths of dullness in the work of some of the commercial engravers who were still alive, for after this year Blake's engraving displays a freedom and a technical lightness which it had seldom enjoyed before.

Although it may be later, Blake may now have written the poem *The Everlasting Gospel* in the *Notebook*. About the same time he took up the small book of engravings originally issued in 1793 and altered the title-page to *For the Sexes: The Gates of Paradise*. He added to the legends on several plates, and engraved three new plates of text to follow the illustrations. A complete copy of this revised reissue contains twenty-one plates.

Blake probably completed the stipple engraving of two plates after C. Borkhardt in the spring, 'The Child of Nature' and 'The Child of Art' since they were published on 2 March. The latter is known only from the inscription, as the rest of the plate has been rubbed down and the space used for a mezzotint, an engraver's technique which Blake is never known to have attempted.

'The Child of Nature.' Stipple engraving
15 × 9¾ ins *British Museum*

On 8 June Blake wrote the letter to Dawson Turner already mentioned in connection with the 'Colour Printed Drawings', in which he offered *America, Europe* and *Urizen* at £5 5s each, *Visions of the Daughters of Albion, Songs of Innocence* and, separately, *Songs of Experience* at £3 3s, and *Thel* at £2 2s. *Milton*, with fifty plates, was priced at £10 10s and the fact that the hundred-plate *Jerusalem* was not included suggests he was still working on it.

Both Blake and Linnell were difficult individuals in their own ways, but the arrival of the latter in Blake's life was almost miraculous. The story had come a long way before it reached the second edition of Gilchrist's *Life*, 1880. W.M. Rossetti got it from Alexander Munro, the sculptor, born 1825, who had heard it from an un-named person who had known Blake, but there is no reason to doubt it. Without Linnell, it seems, Blake would have spent his last years turning out hack-engravings after George Morland who himself had died, in 1804, while turning out paltry parodies of the paintings he had once achieved.

Apart from any business relationship, Linnell was undoubtedly good for Blake as he was obviously a bright companion with whom to visit exhibitions of paintings and of prints. Among other places where they went together was Colnaghi's who had been announced as a distributor of 'The Canterbury Pilgrims' in *The Prologue and Characters* pamphlet of 1812 and who, later, were to own the copperplate itself for a great many years. Blake was not unsociable and enjoyed meeting people; and one of the first whom he met through Linnell was John Varley, painter in watercolors, teacher of that art and a convinced astrologer.

1819 The strange outcome of the ensuing friendship between Varley and Blake was the series of 'Visionary Heads', for which the latter, who scoffed at the idea of being ruled by the stars, provided the drawings while the former added the astrology. The oddest manifestation of these séances, if that is the correct description, was not to be human. 'The Ghost of a Flea', who seems to owe something to the enormous plate in Robert Hooke's *Micrographia*, 1665, for Blake had an extraordinarily retentive visual memory, first appeared as a head which Blake complained interrupted him in his drawing by

Visionary Heads
'Canute.' Pencil drawing
10 × 7⅝ ins *Huntington Library and Art Gallery*

'opening its mouth'. Varley seems to have made use of this drawing, now in the Tate Gallery, for his etching in his *A Treatise on Zodiacal Physiognomy*, 1828. The flea seems to have been persistent, for it also stood for a full-length portrait in the odd sketchbook which Blake and Varley shared and which has been reproduced in facsimile with an introduction by Martin Butlin. In this drawing it appears rather static, as if being forced to hold a pose, but in Blake's imagination it could also appear striding dramatically in front of a star-studded sky cut diagonally by a comet or falling star. It was in this way that Blake showed it in the little tempera which so attracted Graham Robertson in 1892 when he saw it in Quaritch's

'The Ghost of a Flea.' Pencil drawing
$7\frac{3}{8} \times 6\frac{3}{8}$ ins *Tate Gallery*

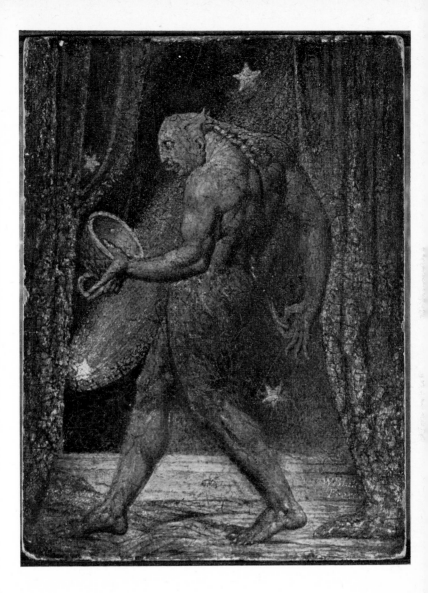

'The Ghost of a Flea.' Tempera
$8\frac{3}{4} \times 6\frac{3}{8}$ ins *Tate Gallery*

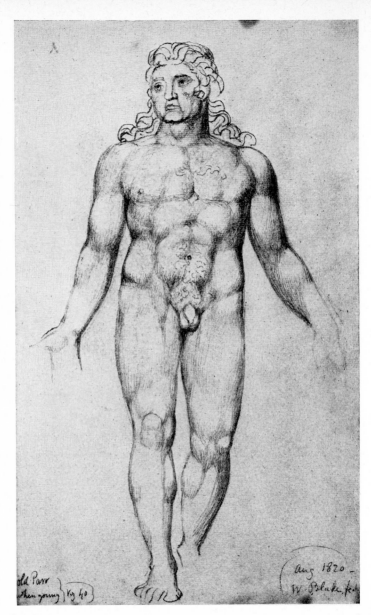

'Old Parr when Young.' Pencil drawing
11¾ × 7¼ ins *Huntington Library and Art Gallery*

bookshop. Feeling terribly extravagant, he spent £12 upon it and became a Blake enthusiast who gathered the finest collection made by anyone since Blake's death. This little fresco, heightened with gold, is painted upon a panel and is probably one of the earliest works done in Blake's 'revised' fresco after he had begun to mistrust canvas as a base. It was bequeathed by Robertson to the Tate Gallery in 1949.

On 27 August Linnell bought *Songs of Innocence and of Experience* from Blake for £1 19s 6d, and on 30 December gave him 14s for Chapter 2 of *Jerusalem*.

In September Blake received a commission from Dr Robert John Thornton, Linnell's family doctor, who was a famous botanist and who had ruined himself in the production of the most sumptuous botanical work ever produced, *A New Illustration of the Sexual System of Linnaeus*, 1799–1807, the third part of which contained twenty-eight color prints, mostly by famous artists, and was also issued separately as *The Temple of Flora*. In the meantime, he had a steady if small source of income in his editions of *The Pastorals of Virgil*, a book designed for schools, first published in 1812.

Now a third edition, lavishly illustrated, was planned. Through the good offices of Linnell, Blake was asked to prepare twenty-seven drawings and twenty-six engravings, although, in the event, three of the latter were carried out, miserable travesties, by another hand.

It is possible that about this time Blake annotated a copy of J.G.Spurzheim's *Observations on the Deranged Manifestations of the Mind, or Insanity*, 1817. A torn sheet upon which some notes were written that had been folded into the MS of *Vala* has not been seen since the 1890s.

1820 Scanty evidence would suggest that at last Blake managed to bring *Jerusalem*, his last vast prophetic book upon which he had been working for so many years, to a conclusion. Thomas Griffith Wainewright, better known today as a poisoner and forger than as a journalist, a painter who had studied under Fuseli and one of Blake's steady patrons during his latter years, writing in the *London Magazine* in September under the pseudonym of Janus Weathercock, drew attention to it in the jocular manner which seems to have been expected of him.

It is likely that the large plate of 'The Laocoön' in which the figures are surrounded by sentences of symbolical meaning belongs to this year. Blake, as has been noted, had made a careful study of the group from the cast at the Royal Academy and had also engraved it for Rees's *The Cyclopaedia*. That the group itself held symbolical meaning for Blake can be seen in the large drawing based upon it which seems to be understood to represent 'Jehovah and his two sons, Satan and Adam, struggling with serpents'. The sentences on the Laocoön plate seem to have some connection with the single sheet of prose issued in relief etching, *On Homer's Poetry* [&] *On Virgil*. Also of about the same date are the opinions expressed in the annotations which Blake wrote in his copy of Bishop Berkeley's *Siris: A Chain of Philosophical Reflexions and Inquiries Concerning the Virtues of Tar Water*, 1744.

The last of Blake's commercial works in the stipple-engraving style is 'Mrs. Q', a portrait of Mrs Harriet Quentin the mistress of the Prince Regent, after Huet Villiers. Although the plate was published on 1 June 1820, it is possible that it was engraved earlier. Since meeting Linnell, Blake had taken a renewed interest in visiting exhibitions of paintings and prints and his own manner of engraving was altering.

By September it would seem that Blake's woodcuts for *The Pastorals of Virgil* were almost completed and Dr Thornton was horrified when he saw them. He suggested to Linnell that they should be redone by lithography. It would seem that as a trial, the head of Virgil was actually proofed on stone, but no copy of this has been traced. The conventional wood-engravers were as scandalized as Thornton and, just to show how they should be done, one of them who fortunately remains anonymous produced the three negligible items mentioned above. There was talk of discarding Blake's works, but luck took Thornton to dinner at the house of Charles Aders, whose wife had become a patron of Blake. There he met Sir Thomas Lawrence, James Ward, Linnell and others who surprised him by supporting Blake and praising his woodcuts. As it happened, Blake's cuts were too large for the book as designed. With the exception of the frontispiece, they had been cut four at a time on single pieces of wood which were later separated. Now they were ruthlessly chopped to fit without regard to the

'Mrs Q' after H. Villiers. Colored stipple engraving
$11\frac{5}{8} \times 9$ ins *Princeton University Library*

'*Laocoön*.' Engraving
$10\frac{7}{16} \times 8\frac{7}{16}$ ins *Sir Geoffrey Keynes*

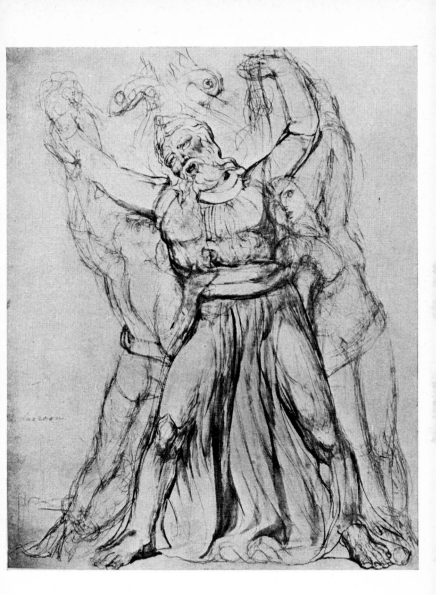

'Jehovah and his Two Sons.' Drawing
20 × 19$\frac{1}{16}$ ins *Sir Geoffrey Keynes*

design. The book was published in the following February with an apologetic note by Thornton explaining that 'they display less of art than genius, and are much admired by some eminent painters'.

1821 Blake's fortunes seem to have been particularly low at this time in spite of all that Linnell could do for him in the way of introductions. The Blakes moved to 3 Fountain Court, Strand, to the first floor up in a house which had been leased the year before by Henry Baines (or Banes) who was married to Catherine's sister Mary.

Possibly the worst blow to Blake was having to sell his collection of prints, which he had been accumulating since he was about ten, to Colnaghi. This blow may have been softened slightly by going round exhibitions in the company of Linnell who also, rather surprisingly, took him to the theater.

The obliging Thomas Butts had lent Blake his set of 'Illustrations of the Book of Job'. Now Linnell commissioned a duplicate set and, to speed things up, spent two or three days at the beginning of September in tracing the outlines. These were then corrected and firmed-up by Blake before he painted them in watercolor.

During the year Linnell purchased *The Marriage of Heaven and Hell* and other 'Illuminated Books' for which he paid £4 18s.

The original Job series having been returned to Butts on 11 September, Blake borrowed a watercolor of 'Cain and Abel'. Between 12 and 14 September Linnell made a watercolor copy from this according to the notes in his journal printed by G.E.Bentley, Jr. It is a little difficult to understand this copy since the watercolor in the Fogg Art Museum, Harvard, would seem in manner and treatment to date from before

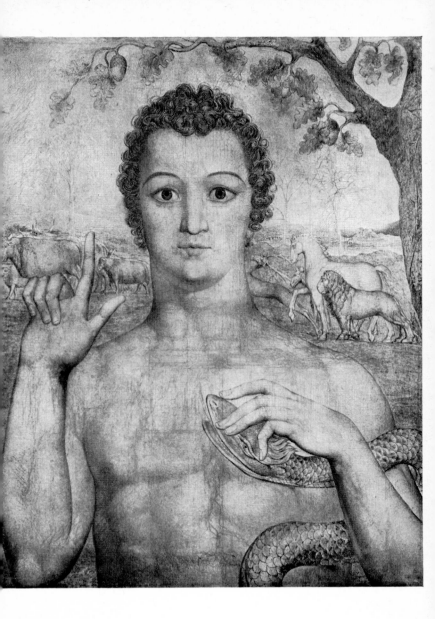

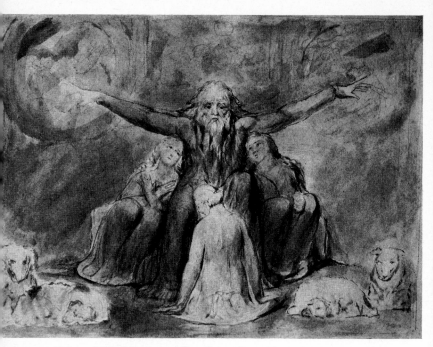

'Job and His Daughters.' Pencil drawing with wash
$7\frac{5}{8} \times 10\frac{3}{8}$ ins *Fogg Art Museum Harvard*

Blake's Exhibition of 1809. The drawing came from the
Linnell collection but there is no record in the Linnell ac-
counts of his purchasing a drawing of that title from Blake nor
is there, in the journal, any mention of the borrowed water-
color being returned to Butts. The Tate Gallery tempera of the
same subject which is done over gold in places, is dated by
Martin Butlin as c.1826, although the use of gold, as in 'The
Ghost of a Flea' (another example of Blake's 'renewed'

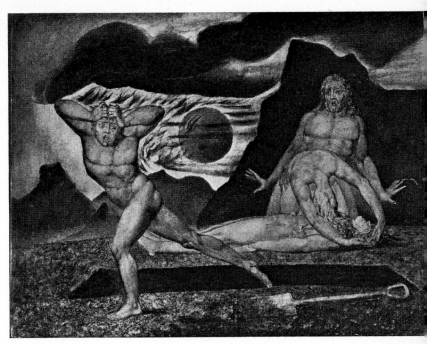

'The Body of Abel found by Adam and Eve.' Tempera
12¾ × 17 ins *Tate Gallery*

fresco), suggests that it may have been done a year or two earlier. Sir Geoffrey Keynes owns a small sepia version, mentioned below, from the Linnell collection. Since neither the Butts watercolor, presumably that shown in the 1809 Exhibition, nor Linnell's personal copy have been traced, it may be possible that the watercolor at Harvard is the former and that Linnell, in recognition of what he was doing for Blake, received it as a gift from Blake's most steadfast patron.

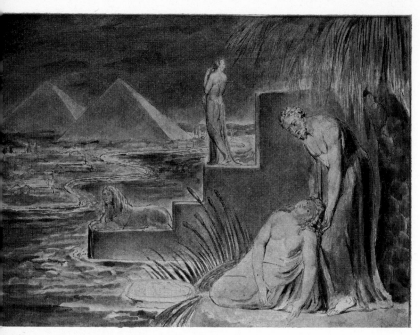

'The Hiding of Moses.' Watercolor drawing
11¼ × 15¾ ins *Huntington Library and Art Gallery*

The *Catalogue* of the Blake collection in the Huntington
Library & Art Gallery suggests that the watercolor of 'The
Hiding of Moses' may be considerably earlier than the tiny
engraving of the same subject, presumably made in 1823 for
Remember Me! A New Year's Gift or Christmas Present which,
although dated 1825, was, according to a prospectus in
the John Johnson Collection in the Bodleian Library,
published in 1824, and being aimed at the Christmas market it
would be dated for the following year. The tiny book was a

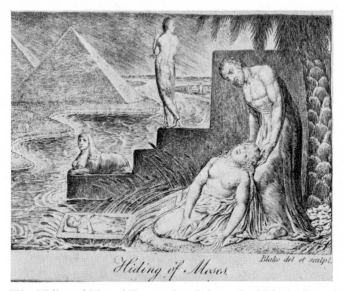

Blake del et sculpt.

Hiding of Moses.

'The Hiding of Moses.' Engraved and drawn by Blake in *Remember Me!* London 1825
2¹¹⁄₁₆ × 3¹³⁄₁₆ ins *Princeton University Library*

venture on the part of Dr Thornton and it is pleasant to find that, much as he disapproved of Blake as an artist on wood, he still admired him as an engraver on copper. An item in Linnell's accounts relating to the 'Book of Job', under 6 July 1823, 'Cash by Dr Thornton's order WB 5.5.' may have strayed there inadvertently and be payment for this plate. The little sepia of 'Cain Fleeing from the Body of Abel' is assumed to have been intended for a future volume of *Remember Me!* which never materialized.

Linnell gave Blake a copy of Cennino Cennini's *Trattato della Pittura*, Rome, 1822, of which he wrote many years later that he believed it to have been the first copy seen in England and that on receiving the gift Blake 'soon made it out & was gratified to find that he had been using the same materials & methods in painting as Cennini describes— particularly the Carpenters glue'. This is a reminder of the remarks made earlier about the difficulty in distinguishing exactly what the various words for 'glue' mean in any language except English. Blake annotated the book but the copy has not been seen since 1907 when the only sentence transcribed was one having nothing to do with painting.

1822 Clearly the subject of Abel was much in Blake's mind at this time for he issued on two plates of uncolored relief etching a dramatic piece, *The Ghost of Abel*. The colophon reads '1822. Blake's Original Stereotype was 1788'. This was probably in answer to an article in the *Edinburgh Philosophical Journal* in 1820 which made reference to John Sievewright, an engraver who was listed in the Edinburgh directories of 1805–15, as having helped W.H.Lizars (1788–1859) in his experiments in stereotype engraving, and was meant to declare Blake's legitimate claim of having predated these.

In April Linnell commissioned Blake to reproduce the series of drawings for *Paradise Lost* which belonged to Butts. Only three were completed, 'Satan watching Adam and Eve' (National Gallery of Victoria, Melbourne), 'The Creation of Eve' (National Gallery of Victoria, Melbourne) and 'Michael foretells the Crucifixion' (Fitzwilliam Museum).

A day or two before Blake started work on the drawings, Linnell took him to dinner with James Vines, 'a Russian merchant', then living in Grenville Street at the corner of Brunswick Square in Bloomsbury. This was a fruitful intro- duction as Vines bought copies of *Thel* and *Milton* and also, in 1826, a proof copy of the Job.

Blake's financial situation was still miserable, however, and Linnell approached the Royal Academy, through William Collins, to see what aid could be offered to a former student

OPPOSITE
'Michael Foretells the Crucifixion' from Milton *Paradise Lost*. Water- color
19¾ × 15⅛ ins *Fitzwilliam Museum, Cambridge*

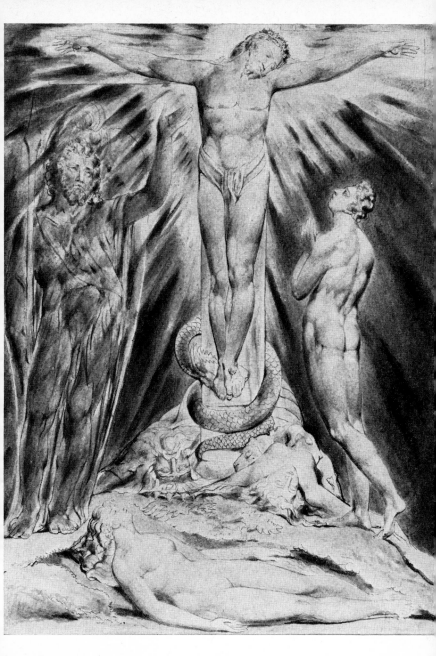

and occasional exhibitor. At the Council meeting on 26 June a letter from William Collins also signed by Abraham Cooper was read in which it was stated that Blake was laboring under great distress. A motion by the sculptor Edward Hodges Bailey, seconded by Henry Bone, that the Treasurer should pay Blake £25 was passed unanimously and the money was duly collected by Linnell.

Although Blake had met Sir Thomas Lawrence before, Linnell, on the look out for new patrons or the chance of turning old friends into patrons, took Blake to dinner at Sir Thomas's house on 13 July.

1823 Undoubtedly Linnell did considerable pondering before suggesting to Blake, in the early spring, that he should make a set of engravings of his 'Illustrations of the Book of Job'. On 14 March he seems to have given Blake £5 to be followed by another £5 on 20 March. These are the first indications of the undertaking. By 25 March matters were clear enough between them for the drawing up of a contract. Under this agreement Blake was to make twenty engravings for which Linnell was to pay him £5 apiece, or £100 for the set, paying the money as Blake needed it, even before the completion of the series. Linnell also undertook to give Blake a further £100 out of the proceeds once 'receipts will admit of it'. In addition Linnell agreed to pay for the copperplates and on the signing of the contract gave Blake £5 with which to purchase the first of these.

At the same time, obviously enjoying the company of his older friend, Linnell took him twice to the British Museum, possibly to examine prints there with an eye on the style to be adopted in the series, to the Royal Academy, the British Institution and probably other exhibitions.

Of course the making of smaller engravings from the set of Job watercolors which he had made earlier for Linnell meant that Blake had to prepare yet another set, of the proper size, and so he made twenty-four drawings, mostly in pencil but some with watercolor and india ink added. These do not con-

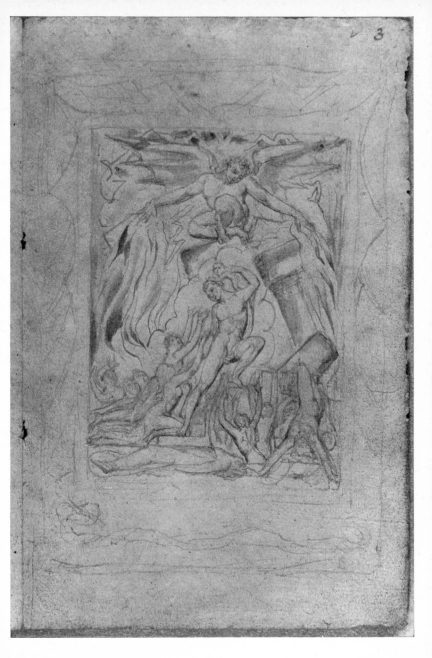

tain a sketch for the engraved title-page but do include an extra design for 'Every man gave him a piece of money' which was not used. Linnell inscribed the wrapper in which the drawings were kept, in ink, 'These are Mr Blakes reduced Drawings / & studies for the Engravings of the Book of Job / Done for me / John Linnell'.

In the summer of this year, James S.Deville made a cast of his head. Deville, who seems to have been a cockney in spite of his French name, owned a lamp shop in the Strand, but his major interest seems to have been in amateur phrenology. He may have known Blake as a neighbor as well as by reputation. Although it has been suggested that the look of discomfiture on Blake's face was due to some of his hair being pulled out when the plaster was removed, the idea is not tenable. The plaster would have set hard and no facial gesture would have had the least effect upon it. Anyone who has ever suffered the making of such a cast knows that both eyes and mouth have to be firmly shut and all breathing done through straws inserted in the nostrils. Furthermore, the freshly mixed plaster achieves a fairly high temperature which, no matter if one has worked with plaster before, is most unpleasant when combined with the claustrophobic effects produced by having one's normal facial activities, seeing, hearing and opening the mouth, so limited, leaving the only communication with the appreciable world to straws which inevitably seem far too flimsy to stand up to the pressure which increases as the plaster dries.

There are two plaster casts of this mask known. The more familiar, of which a modern bronze cast has been made, is in the National Portrait Gallery, and is signed 'A 66 / Pubd. Aug.1.1823.I.Deville / 67 Strand, London'. This was once the property of Linnell. The other, in the Fitzwilliam Museum, belonged to George Richmond and is not so highly finished. It may well be the first impression, taken by Deville once he had reassembled the mould which of course had to be removed from the face in a great number of segments. The yellowing is possibly due to the tallow with which Blake's face was probably coated before the application of the plaster. The taking of the first cast would remove the remains of this from the mould.

1824 It is not certain when Blake met Samuel Palmer. Palmer had a most retentive memory and supplied much of the information about the last years for Gilchrist's *Life*. He certainly knew Blake by May as in that month the two of them went to the Royal Academy and Blake expressed admiration for a painting by T.G.Wainewright, noting 'It was a scene from *Walton's Angler*'. G.E.Bentley, Jr, consulting the catalogues, shows that in the 1824 Exhibition, Wainewright exhibited 'The milk maid's song—. . . "Come live with me and be my love." From the complete Angler. (Isaak Walton and Venator listening.)'. At the time of their first meeting there can be no doubt that Blake was working on the Job engravings as Palmer, then nineteen years of age, specifically mentions that the first plate 'Thus did Job continually' was lying on the worktable.

As a small source of extra income Linnell engaged Blake to help him in engraving his portrait drawing of Wilson Lowry. The latter was an engraver and inventor of, among other things, the ruling-machine to help grave a large number of equidistant parallel lines, straight or curved, with one stroke of the machine. Blake himself had probably known Lowry since at least 1797 when they had both signed the testimonial for Alexander Tilloch and they worked on the same plate for Rees's *The Cyclopaedia*. Blake seems to have done the greater part of the work, for which Linnell paid him £20, and it is an admirable example of the style of engraving which had been developed for the Job.

It is not known when Blake decided to add the engravings surrounding the central subjects in the Job, but it must have been early as these are placed to allow for them. It is certain, however, that the 'Border designs', as Linnell called them, were an afterthought and although sketches for them appear on three of the reduced drawings and there are suggestions for them on one or two of the known early proofs of the central subjects alone, it is correct to say that they were designed directly on the copperplate. No early sketches, apart from these mentioned here are known to exist. Had they done so there is no doubt but that they would have been preserved by Linnell.

Although Blake was hard at work on the Job and on the Lowry plate (published on 1 January 1925, shortly after the

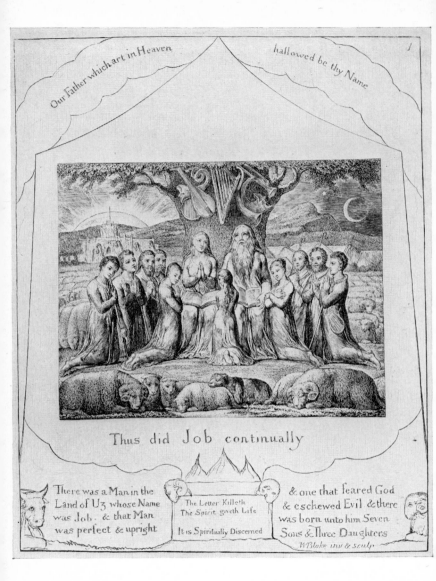

'Thus did Job continually' from *The Book of Job*. Early state of engraving
8½ × 6⅝ ins *National Gallery of Art, Washington, Rosenwald collection*

'Wilson Lowry' engraved by Blake and Linnel after J. Linnell, 1825
$5\frac{3}{4} \times 4$ ins *Princeton University Library*

death of the subject) he was also working upon his frescos. As if this was not enough he also made a series of illustrations for Bunyan's *Pilgrim's Progress*, some of which were left unfinished, and it is even probable that he may have been toying with the idea of illustrating Dante from the summer before. It seems from Gilchrist's account that Linnell, who may have supplied the information himself, agreed then that with the finishing of the Job series he would commission Blake to do a series of designs from Dante.

On 9 October Palmer accompanied Linnell in visiting Blake. They 'found him lame in bed, of a scalded foot (or leg)', he was propped up and the bed was covered with books and 'Thus and there was he making in the leaves of a great book (folio) the sublimest designs from his (not superior) Dante'. Palmer goes on to say that Blake made the rough designs during a fortnight's illness in bed, and Linnell's biographer A.T.Story, giving no source, says that he did all the outline work on the 102 drawings in this position because, owing to his bad foot, he could not sit at his work-table and engrave what remained to be done on the Job plates.

Although by now Blake was nearing his sixty-seventh birthday he had become intimate with a group of much younger disciples and admirers of his work and ideas. These included, as well as Palmer, Frederick Tatham, the son of Blake's old friend Charles Heathcote Tatham, architect and author, George Richmond, Edward Calvert the oldest (b. 1799), and Francis Oliver Finch. Also Henry Walter, John Giles, Palmer's cousin, and Welby Sherman.

The young men called themselves 'The Ancients' and referred to Blake's house as 'The House of the Interpreter'. This last is a clear allusion to *Pilgrim's Progress*, upon which Blake was working.

G.E.Bentley, Jr, suggests that the first issue of *Urania; or, the Astrologer's Chronicle, and Mystical Magazine* appeared in December 1824. This contains the 'Nativity of Mr. Blake, The Mystical Artist'. The subject must have been amused. It has been suggested that the author was Robert Cross Smith, who also wrote under the name of Raphael, and this seems likely as he was a friend of John Varley who probably took him to see Blake with whom he claims to have been acquainted.

'Sweeping the Interpreter's Parlour.' Woodcut on pewter, second
state
$3\frac{1}{8} \times 6\frac{5}{16}$ ins *British Museum*

Factually, the only disputable statement made is that Blake
had a long poem which he affirmed was 'recited to him by the
spirit of Milton' while the author mentions with approbation
the 'Illustrations of the Book of Job', not published until
March 1826.

1825 Work on the Book of Job was proceeding well, and on
5 March Linnell and Blake called upon J.Lahee, the plate-
printer to whom the work of pulling the edition had been
entrusted. The plates themselves bear, in their published state,
the inscription 'London, Published as the Act directs March
8: 1825 by William Blake No 3 Fountain Court Strand'.
In fact they were not published until a year later.

We cannot tell in what order Blake worked upon the engravings once he had decided upon the subject matter and the eventual sequence, already set for him by the existence of the two sets of watercolors. However, he may have become dissatisfied. All his life he had worked with copper and at times the purchase of plates must have been a financial struggle. The mere fact that two of the Job copperplates, all of which are now in the British Museum, are executed upon the backs of plates which, since the other sides show remnants of a work not done by himself or Linnell, makes it clear that he bought them secondhand. Three of the plates, including these, are slightly smaller than the others but, allowing for this deviation, the size of the copperplates must have been discussed by Blake and Linnell at the time of the contract, when the first money for their purchase was provided.

Possibly the size of the plates, rather smaller than that of the watercolors, was the decision of Linnell. He was not a professional engraver. The amount of unused surface which would be left around his central subjects may have irked Blake until he reached a state where he found he had to do something with it. He therefore decided to add marginal and almost outline engravings as a supplement to his detailed central subjects. This decision turned the series from being just an important part of his life's work into a creation of almost unique grandeur.

Apparently, having visited the Royal Academy with Linnell in May, Blake was again laid up in bed with shivering fits in June or July. Being a man determined not to recognize illness, he undoubtedly shared that bed with the folio volume in which he was making his Dante drawings. But by 6 August he was again well enough to accompany Linnell to dinner at Mrs Aders.

For what seem to be legitimate reasons connected with Blake's health and the English climate it has been suggested that Blake, with Edward Calvert and his wife, probably paid a short visit early in September to Samuel Palmer's grandfather in Shoreham, Kent, a place that was later to become important to all of 'The Ancients' but most especially to Samuel Palmer himself.

In October Flaxman bought a copy of the still unpublished Job. Blake, in the same month, went to Hampstead, to North

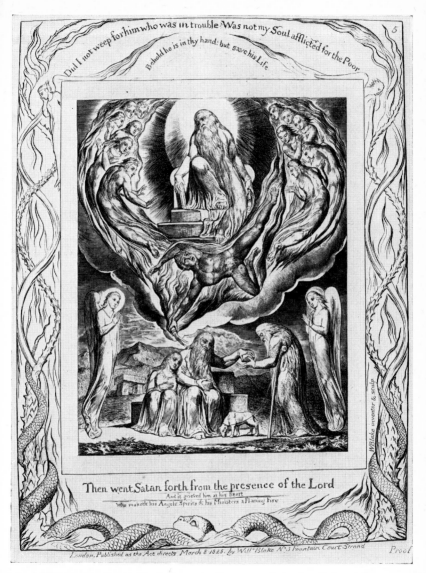

'Then went Satan Forth from the Presence of the Lord' from the *Book of Job.* Engraving
$8\frac{1}{2} \times 6\frac{5}{8}$ ins *Fogg Art Museum, Harvard*

End Village where Linnell was now living, to visit Mrs Linnell and the children while her husband was away in Gloucester. With him he took a sketchbook of drawings after prints which he had made when he was fourteen years old. Most of these seem to have appeared strange to the Linnell children but one highly finished and most detailed drawing of a grasshopper enchanted them. Although Blake had developed a theory that Hampstead was a most unhealthy area he appears to have made the long walk from the Strand to North End Village on most Sundays.

So far as can be made out from what remain of Linnell's well-intentioned but often muddled accounts, he seems to have bought the twelve drawings for *Paradise Regained* for £10. Although Butts had bought all the other series of Miltonic illustrations, he had rejected these. It has been suggested that this caused a coolness between Blake and Butts, yet the continuing willingness of the latter to lend drawings to be copied makes it clear that the matter has been exaggerated. On 29 April, Butts acquired a £5 5s proof copy of the 'Illustrations of the Book of Job', paying £3 3s for it. This was a special concession on the part of Linnell 'because he lent the Drawing to copy'.

Linnell seems to have considered his purchase of the *Paradise Regained* series, although it was probably prompted by some financial crisis in Blake's affairs, as a possible investment, for he continued to hawk them among his acquaintances. As a precaution against such a possible sale he made a careful set of watercolor copies of the series, one of which was shown in the 1913 Blake Exhibition at the Tate Gallery.

Although by this time Blake was thoroughly involved in his drawings for Dante, in conversations with Crabb Robinson he expressed his growing distaste for the poet both as a man and as a vehicle for the ideas which he expressed and represented.

Among several of the late great temperas which were probably done in this year, one is certainly the fascinating 'Black Madonna' in the collection of Mr and Mrs Paul Mellon. This bears, in the lower right corner, the inscription 'Freso [*sic*] / 1825 / W Blake'.

1826 By the beginning of the year orders for the 'Illustrations of the Book of Job' were beginning to reach Linnell regularly

'The Black Madonna.' Tempera on panel
11¼ × 9¼ ins *Mr and Mrs Paul Mellon*

if slowly. Word of the forthcoming book had been going around for a considerable time. As early as 12 October 1823, Edward Hodges Bailey, who had proposed the giving of a grant to Blake by the Royal Academy, had subscribed for a copy and had paid £1 1s as a deposit. He seems to have been the first subscriber and paid the remaining £1 2s 6d in this August.

The printing was going ahead well at Lahee's. From a letter of Mrs Linnell's it would seem that the actual work of printing the plates was carried out by a man named Freeman. It is a pity that no more than this mention of his name and his being given £1 in March of this year is known, for, in comparison with much of the commercial printing of plates at that time, he did an outstanding job.

The muddled Linnell accounts traced and analysed by G.E.Bentley, Jr, give the expenses of publishing the Job as £124 12s 1d, but the accounts are probably incomplete.

The binding gave trouble. Robert Balmanno, who was to leave a vast collection of prints after Thomas Stothard to the British Museum, and who, on 15 November 1823, seems to have been the second person to subscribe, complained in a letter to Linnell on 22 April. He wrote, 'You will not be offended if I say, your binder has put you to great expense in doing them up, & has thereby *to me* very greatly lessened the pleasure I should have taken in them. The back is so squeezed & pinched, the prints crackle & wrinkle [?] every time they are turned over, & *must* in a short time be much damaged. I cannot handle the book without pain.'

On 14 July Blake signed a receipt acknowledging that in return for his having received £150 the copyright and the plates had become the property of John Linnell. The need for this may have been the imprint which claimed Blake himself as publisher.

As a mark of his delight at finally seeing the 'Illustrations of the Book of Job' completed, for it was the first and only book of his own designs and engravings ever to be offered to the public (apart from the uncompleted *Night Thoughts*), Blake presented Linnell with the MS of *Vala* or *The Four Zoas*. Although Linnell must have appreciated the gift he must also have been sorely puzzled by everything except the drawings.

In July Mrs Aders bought a copy of *Songs of Innocence and of Experience* for £5 5s. This is now in the Fitzwilliam Museum, beside the copy which Linnell bought for £1 19s 6d in August 1819.

During July Blake was again ill and again seems to have taken the folio volume of Dante drawings to bed with him. When at the beginning of August he was finally able to get to Hampstead he carried the folio with him and continued working while seated under a clump of trees. A little later Blake visited the Calverts at their home in Brixton and while Calvert and his guest were heating an etching ground over the fire the pottery jar they were using cracked and the mixture set the chimney ablaze. Blake's only concern was that Mrs Calvert, who had gone to bed, should not be alarmed.

Ackermann, who had bought the plates for *The Grave* in 1813 and had issued a new edition then, now produced an odd item. He employed the Spanish refugee poet José Joaquin de Mora to write a poem, in Spanish, solely to accompany the engravings. *Meditaciones Poeticas*, besides being for sale in London, was also distributed in Mexico, Columbia, Argentina, Chile, Peru and Guatemala, but not in Spain.

In the meanwhile Linnell's cultivation of Sir Thomas Lawrence produced a beneficial result. The President of the Royal Academy, who was also one of the most distinguished collectors of drawings of his time, bought two watercolors from Blake, 'The Wise and Foolish Virgins' and 'Queen Katherine's Dream', paying £15 15s each for them. Earlier in the year Sir Thomas Lawrence had ordered a copy of the Proofs of Job, and another had been presented to the Royal Academy. Sir Thomas sent Linnell £10 10s and the latter, after some mathematical self-justification, decided that although the money might have been meant for the copy given to Sir Thomas for the Academy, Blake should keep £5 5s of it.

When Crabb Robinson heard of the death of John Flaxman he called on Blake, 7 December, to find how he would react to the news. Recalling his own serious illness of the summer, Blake smiled and remarked, 'I thought I should have gone first'. He then commented, 'I cannot consider death as anything but a removing from one room to another'.

As Blake had continually expressed his disapproval of

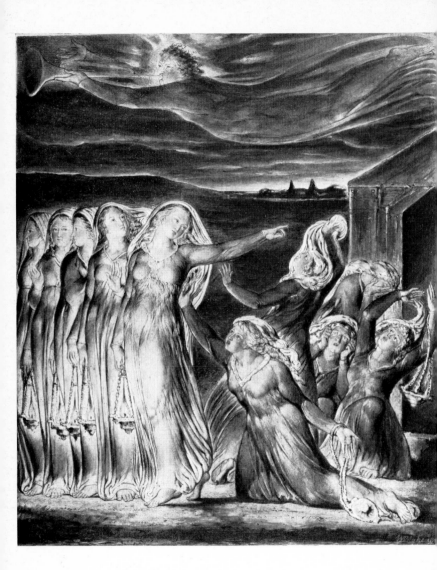

'The Wise and Foolish Virgins.' Watercolor
$16\frac{1}{8} \times 13\frac{7}{8}$ ins *Philip Hofer, The Houghton Library, Harvard*

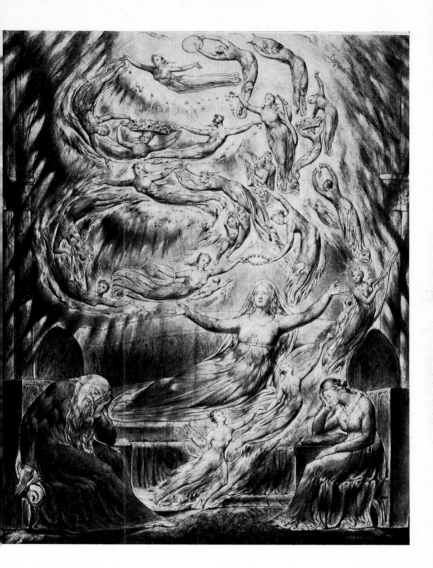

'Queen Katherine's Dream.' Watercolor
16 × 13 ins *National Gallery of Art, Washington, Rosenwald Collection*

Wordsworth's ideas, Crabb Robinson in an effort to convert him had lent him *The Excursion*, 1814, and the two-volume *Poems*, 1815. Blake annotated both of these before returning them to their owner whom he cannot have expected to agree with his comments.

1827 Blake who had disagreed with Dr Thornton about art found himself even more at odds with him and expressed his feelings in his annotations on Thornton's *The Lord's Prayer, newly translated From the Original Greek*, 1827.

Linnell was much worried about Blake's declining health. Yet Blake still persisted in his work upon the Dante drawings and on the seven large plates, over 9 × 13 ins each. Of the latter, he was only able to bring 'The Whirlwind of Lovers', illustrating Canto v, line 137, to anything like completion, but, even in their unfinished state, all seven are most impressive and show that Blake's burin (or graver) was as sure as it had ever been. The actual technical achievement in the engravings even seems in passages to surpass that of the 'Illustrations of the Book of Job' as if Blake, in the marginal designs for the latter, had learned a new value for open space. The actual copperplates are now in the National Gallery of Art: Rosenwald Collection and, as a small edition pulled from them in 1968 by Harry Hoehn proves, are still in excellent condition after some 300 impressions have been taken from them.

Three entries in Linnell's accounts for this year, 20 June, 3 August and 4 September 'to Lahee for Proofs', clearly refer to the Dante engravings. Although it is known that Blake at this time owned a large and by then old-fashioned press, it is doubtful whether he had it set up in Fountain Court. It would have dominated any room, and no mention of it is made in any of the known precise descriptions of the two rooms. By this time also it is highly improbable that Blake would have had the strength to turn the windlass or flywheel of any large press. In my opinion, after leaving Felpham Blake never did have an etching-press set up. The relief etchings of the following years and the pewtercut of 'The Man Sweeping the Interpreter's Parlour' required little pressure to print: an ordinary book-press would have served, or they could even have been printed by hand-rubbing. Only in Lambeth and in his cottage at Felpham does Blake seem to have had the opportunity

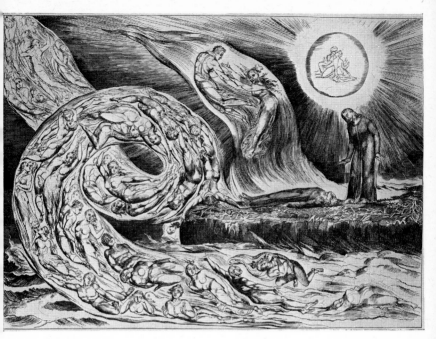

'Paolo and Francesca' also known as 'The Whirlwind of Lovers'.
Engraving
$9\frac{7}{8} \times 12\frac{10}{16}$ ins *National Gallery of Art, Washington, Rosenwald Collection*

and space in which to set up anything like a professional print-shop.

On 8 February, obviously feeling pretty sure of success, Linnell took the twelve drawings of *Paradise Regained* round to the house of Sir Thomas Lawrence. His price for the series was £50, which would have shown a remarkable profit on the £10 he had spent less than two years before. Sir Thomas was not enamored and rejected them. They remained in the Linnell family until the sale at Christie's in 1918, when they were bought by T.H.Riches, who was married to one of Linnell's granddaughters, for £2,105. Although it was ninety-three years later, even allowing for all possible decreases in the purchasing power of money, the original investment gave a most handsome return. The drawings are now in the Fitz-william Museum.

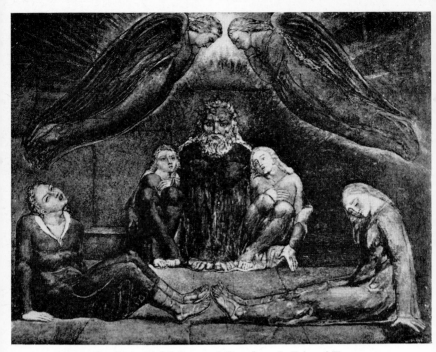

'Count Ugolino with his Sons and Grandsons in Prison.' Tempera on panel
13 × 17¼ ins *Sir Geoffrey Keynes*

An anonymous writer, who may have been William Paulet Carey, mentions a vist to Blake earlier in the year. He gives a vivid description of Blake's surroundings, without mentioning a press, and comments on his books which, we know from other sources, were kept in piles rather than in a bookcase. At the top were his Bible, his copy of *Dante* con l'Espositioni di Christoforo Landino, et d'Allessandro Vellutello, and *The Vision; or Hell, Purgatory, and Paradise*, tr. H.F.Cary, 1819.

Ill and weakening though he was, Blake still persisted in his work, and it seems that the tempera on a panel, with the incised inscription 'W BLAKE fecit', of 'Ugolino and his Sons in Prison', may have been done in this last year.

Through T.G.Wainewright, Linnell heard that the King's

George Cumberland's Message Card
1⅜ × 3⅛ ins *Museum of Fine Arts, Boston*

physician, Dr Robert Gooch, was fascinated by Blake whom he seemed to know well as he had expressed great admiration for his Dante and also had, it seems, ordered colored copies of the *Songs*, *The Marriage of Heaven and Hell* and others, rather too late in the day.

On 17 April, Linnell took Blake to meet William Young Ottley. As a result Ottley, whom Gilchrist describes as a very slovenly Keeper of the British Museum, ordered an uncolored copy of *Jerusalem*, although the payment of £5 5s arrived only on the day before Blake died.

In the early spring, George Cumberland had sent Blake the little copperplate of his calling card with the lettering 'Mr Cumberland' in bastard gothic, requesting that Blake should

do something with it. On 12 April, Blake wrote to him, 'The Little Card I will do as soon as Possible but when you Consider that I have been reduced to a Skeleton from which I am slowly recovering you will I hope have Patience with me'.

Blake did not neglect his old friend and surrounded the lettering with minute symbolical figures. In the lower right corner, over-estimating his age, he inscribed 'W Blake inv & sc: / A Æ 70 1827'. This was the last time he handled a burin and it is likely that he was happy to end as he had begun, as an engraver.

On 10 August Linnell, in his usual laconic manner, noted in his journal, 'To Mr Blake. Not expected to live'.

It seems, however, that though he knew himself to be weakening the urge to work persisted in Blake, for Gilchrist records 'One of the very last shillings spent was in sending out for a pencil'.

It was probably before these last days, while 'Blake worked when bolstered-up in his bed' that, according to Frederick Tatham, he colored the print originally designed as the frontispiece for *Europe*. This was in at least six cases issued separately, colored by hand and was then generally known as 'God Creating the Universe' or 'The Ancient of Days'.

William Blake died on Sunday, 12 August, before he reached the age which he had assumed on Cumberland's little card. He was buried on 17 August in Bunhill Fields, the undertaker's bill coming to £10 18s.

Apart from an anonymous but appreciative obituary in the *Literary Gazette* (18 August) the only other reasonably accurate notice, also anonymous, appeared in the *Literary Chronicle* of 1 September.

On 26 December Cumberland wrote to his son, instructing him, without entering into any business with Linnell, to pay Mrs Blake £2 12s 6d for a copy of the Job and £3 3s for his card. This was done on 17 January 1828.

Of the immediate fate of the works left on his death, it has already been recorded that Lord Egremont bought 'Spenser's Faerie Queen'. Henry Francis Cary, the translator of Dante, bought the early drawing 'Oberon, Titania and Puck with Fairies Dancing' now in the Tate Gallery. Later, in 1830,

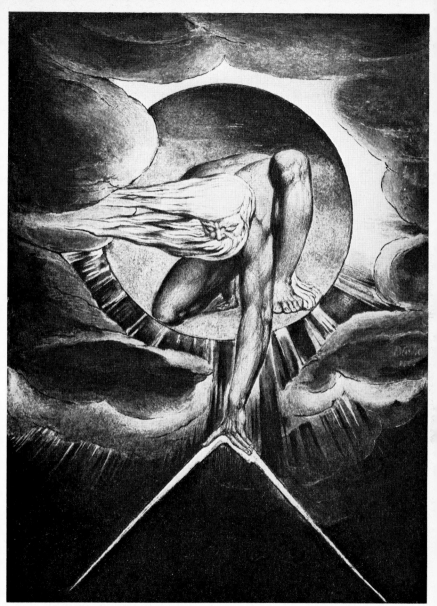

'God Creating the Universe' from *Europe*. Watercolor, black ink and gold paint over an etched print (probably printed in yellow) $9\frac{1}{4} \times 6\frac{5}{8}$ ins *Whitworth Art Gallery, University of Manchester*

John Jebb, Bishop of Limerick, bought two watercolors, unfortunately not identified, and the prints of 'The Complaint of Job' and 'Ezekiel, I take away from thee the Desire of thine Eyes', now in the Fitzwilliam Museum, and *Songs of Innocence and of Experience*, in King's College Library, Cambridge, paying a total of £21. He bought other things, but no records exist to show what they were or what he paid.

Catherine Blake died on 18 October 1831, aged sixty-five, and was buried in Bunhill Fields on 20 October.

Frederick Tatham insisted that the widow had left everything to him, and all efforts to separate him from the drawings, copperplates and remaining engravings in favor of Blake's sister Catherine, or Linnell, to whom Blake was still indebted after his death, were a failure. The only exception was that John Linnell, after much correspondence and unpleasantness, managed to obtain the Dante drawings and copperplates. In his disposal of the works which he insisted he had inherited, Tatham seems to have been more than haphazard, disposing of them here and there as he needed money.

G.E.Bentley, Jr, admitting there are a tremendous number of omissions, finds documentary evidence that during the years 1802–27 Blake was paid about £1531 15s. Frederick Tatham probably obtained more from the remains of the man, for whom he never seems to have felt any deep sympathy.

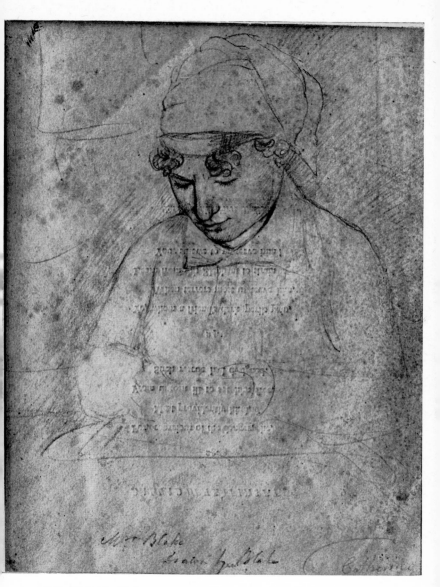

'Mrs Blake' by Blake
$10\frac{1}{16} \times 8\frac{1}{16}$ ins *Tate Gallery*

Acknowledgments

It seems ungracious that so much effort should have to be acknowledged in a mere alphabetical listing of names, but my gratitude to all those mentioned and to any whom I may have inadvertently omitted is none the less deeply heartfelt. So, for so many things, I thank: A.A.Auld, G.S.Barber, Guy Barton, Gregory Bateson, G.E.Bentley, Jr, Christine Bernard, Roger Billcliffe, David Bindman, W.H.Bond, Kirstine Brander, Peter Bromhead, Martin Butlin, Herbert Cahoon, Peter Canon-Brookes, I.O.Chance, Rollo Charles, Earle E.Coleman, Malcolm Cormack, John Craxton, Edward Croft-Murray, Merlin Cunliffe, Bernice Davidson, Nicholas Draffin, Mary Ann Elliott, David Erdman, Edward A.Foster, Eleanor M.Garvey, Robert G.Goelet, George Goyder, Janet Green, Margaret Greenshields, Robin Greer, Paul Grinke, Rosamond D.Harley, John Harris, Marvel A.Hart, Isabel Henderson, Harry Hoehn, Philip Hofer, Ursula Hoff, Lawrance Holmes, Robert Hutchinson, Elizabeth Johnson, David Jolley, Geoffrey Keynes, Annabel Lea, Frances Lincoln, Mary E.Maher, Kneeland McNulty, Paul Mellon, Paul Miner, Thomas Minnick, J.L.Naimaster, John Nicoll, Alan L.Paley, Morton D.Paley, Leslie Parris, John F.Peckham, David Piper, Kerrison Preston, E.G.Purdie, Kathleen Raine, Graham Reynolds, Howard C. Rice, Michèle Roberts, Lessing J. Rosenwald, Charles Ryskamp, Tom Scott, P.Selby-Smyth, Jennifer Sherwood, Philip F.Siff, Charles Singleton, Fay Stanley, John Summerson, A.A.Tait, Christopher Todd, Evan H.Turner, Willis Van Devanter, Robert R.Wark, Caroline Westmacott, Clovis Whitfield, John Hay Whitney, E.I.Wicks, Eunice Williams, Shirley Woolmer, Alfred J.Wyatt and Mabel Zahn.

I am, of course, deeply indebted to the various places where some of these people work, for without their implicit approval I would not have received the personal help which so many of my problems have required.

Finally, although the Award was given to me in aid of my other Blake researches, I must thank the Ingram Merrill Foundation most sincerely. Owing to the overlapping of these researches, this little book has been a supplicant which has benefited unexpectedly, and most joyously.

Bibliographical note

Since any attempt at a bibliography of William Blake here would be an absurdity, the obvious starting place is in the two bibliographies which exist: Geoffrey Keynes *A Bibliography of William Blake* New York, 1921 (reprinted, New York, 1968) and G.E.Bentley, Jr & Martin K.Nurmi *A Blake Bibliography* Minneapolis, 1964. This last is, I believe, being revised and brought up to date, but in the meanwhile most of the new material has been recorded in *Blake Newsletter*, edited by Morton D. Paley, University of California, Berkeley, an invaluable periodical for all who are truly interested in Blake, and which will, after the appearance of the new edition of *A Blake Bibliography*, continue to list new, and newly discovered, material.

The first full biography, *Life of William Blake*, by Alexander Gilchrist was completed after his untimely death by his widow with the help of Dante Gabriel and, even more, his brother William Michael Rossetti. The original edition was published in London in 1863, and revised and enlarged in the second of 1880. In 1907, W.Graham Robertson edited a reprint of the 1863 edition, illustrating it largely with pictures from his superb Blake collection. Using the 1880 edition Ruthven Todd produced annotated editions for 'Everyman's Library', London and New York, 1942, revised 1945. The same editor is at present engaged in a complete revision, to be published by the Clarendon Press, Oxford.

The Life of William Blake by Mona Wilson, was published by the Nonesuch Press, London, in 1927, and a cheap edition was issued in 1932; a revised edition appeared in 1948, and a further revision, edited by Sir Geoffrey Keynes, was published by the Oxford University Press in 1971.

A source book of all the contemporary references, and an indispensable tool for all Blake students is *Blake Records* by G.E.Bentley, Jr, Clarendon Press, Oxford, 1969.

For all Blake's works in poetry and in prose there are two books which are needed and which balance rather than compete with each other. The senior of these is *The Complete Writings of William Blake*, edited by Geoffrey Keynes, first published by the Nonesuch Press in 1957. This was reprinted photographically and republished by the Oxford University Press, new material being added in a supplement, 1966; further new material was added to the first paperback, 1969. *The Poetry and Prose of William Blake* edited by David V.Erdman, with a commentary by Harold Bloom, New York, 1965, also remains a book to which new material is continually being added and with the

appearance of the fourth printing, with revisions, 1970, it too became available as a paperback.

For anyone working on the writings, a necessity is *A Concordance to the Writings of William Blake*, edited by David V.Erdman, with the assistance of John E.Thiesmeyer and Richard J.Wolfe, also G.E. Bentley, Jr, Palmer Brown, Robert F.Gleckner, George Mills Harper, Karl Kiralis, Martin K.Nurmi, and Paul M.Zall, Ithaca, New York, 1967. The book is based upon Sir Geoffrey Keynes's Nonesuch edition of the *Writings* and, since the Oxford University Press edition is a reproduction of that photographically, it remains valid. Appendix B, at the end of Vol. II, provides 'Corrections and Additions to the Keynes Text'.

It would be invidious to try to select a few books which deal with Blake as an artist, but an exception must be made in mentioning Sir Anthony Blunt's *The Art of William Blake*, New York, 1959, which examines the visual sources of Blake's graphic works and inspires the reader to seek further.

One of Blake's receipts to Thomas Butts
$3\frac{3}{16} \times 7\frac{5}{8}$ ins *Author's collection*

Index to Blake's works mentioned in the text

158

STUDIO VISTA | DUTTON PICTUREBACKS

edited by David Herbert

British churches by Edwin Smith and Olive Cook
European domestic architecture by Sherban Cantacuzino
Great modern architecture by Sherban Cantacuzino
Modern churches of the world by Robert Maguire and Keith Murray
Modern houses of the world by Sherban Cantacuzino

African sculpture by William Fagg and Margaret Plass
European sculpture by David Bindman
Florentine sculpture by Anthony Bertram
Greek sculpture by John Barron
Indian sculpture by Philip Rawson
Michelangelo by Anthony Bertram
Modern sculpture by Alan Bowness

Art deco by Bevis Hillier
Art nouveau by Mario Amaya
The Bauhaus by Gillian Naylor
William Blake: the artist by Ruthven Todd
Cartoons and caricatures by Bevis Hillier
Dada by Kenneth Coutts-Smith
De Stijl by Paul Overy
An introduction to optical art by Cyril Barrett
Modern graphics by Keith Murgatroyd
Modern prints by Pat Gilmour
Pop art: object and image by Christopher Finch
The Pre-Raphaelites by John Nicoll
Surrealism by Roger Cardinal and Robert Stuart Short
Symbolists and decadents by John Milner
1000 years of drawing by Anthony Bertram
Andy Warhol by Peter Gidal

Arms and armour by Howard L. Blackmore
The art of the garden by Miles Hadfield
Art in silver and gold by Gerald Taylor
Costume in pictures by Phillis Cunnington
Firearms by Howard L. Blackmore
Jewelry by Graham Hughes